# PAiNT!

# STILLLIFE

Book design by Brenda Dermody, Dublin. Production and separations in Singapore by ProVision Pte. Ltd. Tel: +65 334 7720 Fax: +65 334 7721

# PAiNT!
## STILL LIFE

**BETSY HOSEGOOD**

RotoVision

contents

# Introduction

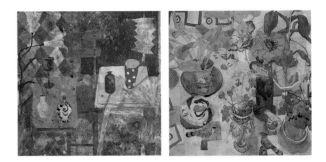

Flowers erupting from a crystal vase; a pretty tea tray on a table in the garden; a poacher's bag with that day's catch spilling out; even pots or bags of take-away food... these are all topics which have inspired artists both past and present and which may inspire you. Such is the versatility of still life arrangements that artists can choose whatever interests them as the subject matter – cooks can depict bowls, wooden spoons and cooking utensils, gardeners can create arrangements of their favourite flowers or well-loved garden tools, while writers might be more inspired by a traditional ink pen and ink bottle with some handmade paper or a group of books as their subject.

The still life has many further attractions. For example, there is no need to worry about the weather interrupting progress if you paint indoors, and if you wish you can work in a private room without fear that prying eyes will interrupt your concentration or make you feel self-conscious. There is no need to travel to reach your subject and, provided that the subject matter isn't perishable, you can work in short bursts over a number of days, weeks or months if that suits your lifestyle.

Don't think for too long over the subject matter of a still life – if you try too hard it can be difficult to settle on any one selection. You'll find that as you progress you start to find favourite items which crop up again and again in your work. Additionally you'll find that as you paint one subject an idea for another picture materialises in your mind. Some still life artists work in series for this reason, exploring a theme over a number of paintings and even becoming so attached to a subject that they specialise, becoming a flower painter or cookery illustrator, for example. The main thing is to paint what inspires you and to allow your feelings to come across as you work, either through the choice of colours or the way you apply the paint. If you really find it difficult to get started, simply pick up one object and then build round it, using the object's colour as your theme or choosing items with the same function, such as a selection of pots.

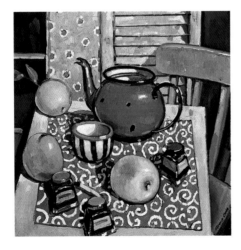

## About this book

This book examines the work of a number of artists working in all the main mediums plus mixed media to show a variety of ways in which this subject is tackled and to provide an insight into each artist's motivations, inspirations and technique. The work of each artist is examined over eight pages. The first two provide brief background information and show the painting as large as possible so you can really see the detail and texture of the paint. The next two pages concentrate on the composition of the painting, using diagrams to help demonstrate a few main points. This is followed by an examination of the artist's use of colour and then an explanation of his or her technique. As far as possible the artists are allowed to speak for themselves as if they are taking you on a personal tour of their work. Quotes from the Great Masters provide further inspiration and insight into how artists regard their work.

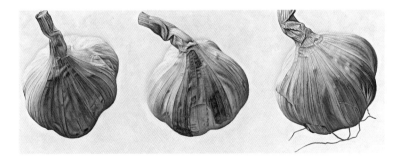

# Composition

After providing some background information about each painting or artist this book turns first to composition. It is the composition which gives a painting its rhythm and therefore its energy. Many still life artists want their paintings to be contemplative with a calm rhythm in the traditional mode, but others want to instil energy and vigour into their work to produce a strong emotional response, and they opt for a far more dramatic rhythm.

Basically you'll find that verticals and horizontals in a painting create a calm mood while dramatic diagonals add energy. A landscape is usually relaxing to look at because of the gentle rhythms provided by the straight horizon or gently rolling hills and the verticals or near-verticals of the trees. Conversely, an image of rushes or irises with leaves thrusting out in all directions has a lot more energy and power. This is because the sharp angles suggest movement – think of the way in which a person leans forward to run or strike out at an enemy. You'll find that you use these means to create the required level of energy in a painting quite instinctively, but it is useful to keep them in the back of your mind in case the rhythms don't seem right and you don't know why.

### Geometric patterns

Artists often arrange still life objects to form a basic geometric shape because these forms are familiar and therefore seem right. Triangles and circles or ovals are perhaps the most popular because they generally incorporate odd numbers, and as any designer or gardener will tell you, arrangements involving odd numbers usually look more natural. In addition, arrangements of an even number of objects often end up being symmetrical and symmetry in a painting can produce a static mood. If this is your aim and it suits your style then that's fine, but usually you'll find that at least some break in the symmetry works best.

Two compositional devices which are frequently used are the Golden Section (also called the Golden Mean) and the rule of thirds. The Golden Section was formulated by Vitruvius in the first century BC. He said that the harmonious relationship of unequal parts of a whole was achieved if the smaller was in the same proportion to the larger as the larger was to the whole. In mathematical terms this creates the sequence one, two, three, five, eight, 13, 21, 34 and so on which interestingly is a sequence often found in Nature – how a shell increases in size or a tree forms a series of branches and twigs.

On canvas these proportions are created using a compass and ruler to divide the support into four unequal parts with one vertical and one horizontal division (see diagrams). Artists can either place the key focus where the lines intersect or arrange several subjects so that they fit into the different sections. They might place the edge of a table along the horizontal line for example, so that the table surface falls into the lower sections and position a large item so it fills one of the top sections or is dissected by the vertical line.

The Golden Section is complicated, so most artists today tend to use the more straightforward rule of thirds instead which is based along similar lines. Basically if you divide the support into thirds both vertically and horizontally, then the points where the vertical and horizontal lines intersect are considered the most pleasing positions for a focal point (see diagram 1).

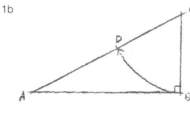

### Rule of thirds

The rule of thirds suggests that if you mentally divide the support into thirds then the most pleasing positions for focal points are where the dividing lines intersect. You don't have to place something in each position – in fact it is usually better if you don't – but it is useful to place one or two important items here. You can also use the dividing lines to mark different sections of the image, such as the edge of a tabletop, for example.

### The Golden Section

The Golden Section refers to a precise division of the support along mathematical lines to create what can be considered the perfect proportions. To create a support divided along these lines refer to the diagrams below. Draw the measurements on paper first and then you can transfer them to several supports. Read through all the instructions before you begin to ensure that you draw your first line AB in an appropriate position on the paper.

First decide on the width of the picture area and draw a horizontal line on paper this long from A to B (you can work to scale).

Draw a vertical line from B to C which is half the length of AB. Join C to A with a straight line. Now take a compass and put the point at C with the pencil end at B and draw an arc that intersects the line CA. Label this point D.

Now put the compass point at A with the pencil end at D and draw an arc that cuts through AB at E to a point directly below A at F. EB is in the same proportion to AE as AE is to AB.

Insert the compass point at E with the pencil at B and draw an arc to a point directly below E at G. Complete a rectangle as shown. Transfer the rectangle to your support complete with the horizontal and vertical lines and use them to plot your composition along the lines of the Golden Section.

1a

1b
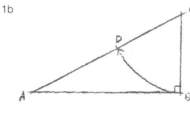

1c
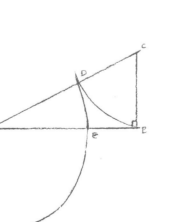

1d
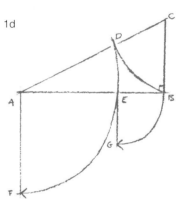

1e
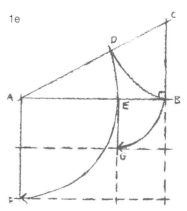

# Colour

Mixing the colours for any painting requires some knowledge of colour theory and a good bit of practice. With still life subjects in particular there is no need to paint exactly what you see because nobody will know exactly what colour the flower or vase was anyway, but you still need to be able to mix up the colours you are aiming for. You also need to get the tone right otherwise the object will lose its shape. In addition, many artists find that it is useful to start off painting what is actually in front of them even if they eventually do alter the colours to work to a particular colour harmony.

There are a few things you should be aware of when buying or mixing paints. For example, be conscious of a colour's chroma – its purity and intensity (saturation). Colours with a high chroma, such as phthalo blue or quinacridone crimson have high chromas and mix together to produce other colours with high chromas. These particular colours are also transparent which makes them seem even lighter and brighter. So if it is your aim to produce a painting with the brilliance of a stained-glass window, for example, then select as many of these colours as possible. If, in contrast, you like muted, subtle colours, then weight your palette in favour of the earth colours and cadmiums such as yellow ochre, burnt sienna, raw umber and cadmium yellow.

You should also consider a colour's tinting strength. Don't be fooled into thinking that if you mix equal amounts of two colours you will get the colour exactly in-between – an orange from mixing a red and a yellow, for example.

A strong colour such as quinacridone violet mixed with equal proportions of a weak colour like Naples yellow will end up weighted heavily towards the stronger colour. In other words you will have a slightly muted red. Some colours, such as terre verte can be added to a mix in quite large quantities without fear of overwhelming it, while even a dab of Prussian blue will flood a mix. A colour isn't bad because it is weak or good because it is strong but what you need to do is use each according to its qualities. The colour terre verte is traditionally used for underpaintings in oils because of the very fact that it is a soft colour which can be easily overpainted, while strong colours can be used to add splashes of brilliance.

Another important factor is permanence which usually refers to lightfastness. Some colours still have a sadly low permanence but they are popular so manufacturers continue to produce them. Where possible select colours with the best permanence to ensure the continued brilliance of your work. Paints vary from brand to brand and from series to series so ideally refer to the manufacturer's details for each paint. Colours also respond differently in different binders – an acrylic may have a stronger permanence than the same colour as a watercolour – so if you work in different mediums you will need to check each colour for each medium. There is a brief summary of colour characteristics at the back of the book, but use this only as a guide because it cannot be accurate for all brands and all mediums.

## A palette for still life painting

One of the things this book shows is that an artist's palette is as different as his style. There are often several paths to mixing the same hue depending on your palette, but a useful basic palette for still life work might include cadmium lemon, cadmium yellow, cadmium red, alizarin crimson, yellow ochre, burnt sienna, French ultramarine, cerulean blue, viridian, ivory black and white. If you are just starting out as a painter you could take some of these colours as your starting point or simply adopt the palette of an artist in this book whose work you admire. You'll find that as you progress you soon develop your own palette as it is hard to resist picking out a few extra colours when viewing what's on offer at the local art shop.

cadmium lemon          cadmium yellow

French ultramarine      cerulean blue

## Using the colour wheel

Nothing can help the artist better than experience derived from experimentation with colour but an understanding of the colour wheel will let him or her know what to expect. It shows that mixing blue with yellow in various proportions produces a range of greens, for example. However, it is experience which will later reveal that to mix the clearest greens the artist must combine a greenish yellow such as lemon yellow with a yellowish blue such as cobalt or Prussian blue.

The colour wheel is also useful for finding a colour's complementary. Colours are best toned down by adding some of the complementary hue which appears opposite it on the colour wheel. The more you add, the closer it approximates to brown, grey or green; the less you add, the more it resembles its parent colour. Adding the complementary colour is also one of the best ways of producing natural-looking hues; mixing colours randomly can produce some very unnatural-looking shades.

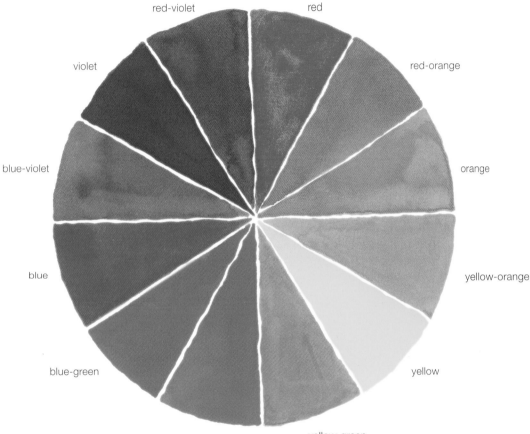

cadmium red

alizarin crimson

viridian

yellow ochre

burnt sienna

Mars black

# Artist's Own Technique

Whether you simply enjoy looking at paintings or whether you want to be an artist yourself, this section should be of interest to you. If you are an art lover, finding out a little more about how paintings are made will heighten your appreciation while if you want to paint yourself you'll gain some insight into how different artists work. Of course, the only way to develop a personal style and to really learn is to practice and experiment, but watching other artists will provide a few pointers.

### Oil techniques

Oil paintings are held in the highest regard by most art collectors and usually carry the highest price tag. This is partly because oil has a long tradition but also because the paintings last well and take a long time to produce. Many beginners are fearful of trying oil because of its reputation as a serious medium but in fact, because the paint takes a long time to dry, it can be manipulated for as long as it takes to get it right. Provided it hasn't been applied too thickly it can also be overpainted at will, making it easy to modify as you work.

### Watercolour techniques

Watercolour was once associated mainly with sketches and as the hobby of ladies of leisure, but it is now taken much more seriously. It is by no means easy to master because mistakes are difficult to rectify but it is capable of producing some wonderful effects which makes it well worth the effort. Washes of paint can be allowed to spread and merge creating exciting new colours and interesting patterns like blooms and backruns. With the white of the paper for highlights, watercolour is particularly good at capturing the effects of light and in the hands of a master it has a wonderful luminosity which is difficult to match in any other medium.

### Acrylic techniques

This medium often causes concern because it's so modern that people don't know much about it or how long it will really last. There is also a certain amount of snobbery in the art world which suggests that oil is the true aristocrat while acrylic is its very poor cousin. However, acrylic is fast gaining ground, mainly because it is popular with artists for its quick-drying properties and versatility – it can be diluted to handle like watercolour or thickened to act like oil.

One possible drawback with acrylic is that the dried paint can absorb dust and dirt from the atmosphere which is then impossible to remove. This can be easily avoided by varnishing the finished piece. This not only protects the paint but also enriches it, giving it a sheen which captures much of the look of oils. In years to come, if the painting does absorb dirt the protective layer of varnish can be removed and replaced to restore the painting to its former glory in the same way as with an oil painting.

### Drawing media

Many artists, particularly those with an illustrator's background, are attracted to drawing media because of the precision that is possible. With ordinary coloured pencils an artist can create masterful pictures by overlaying tiny marks of colour which blend together almost imperceptibly. This is not a rapid process – Peter Woof's pencil drawings take many hours to complete. Pastel is also usually placed in this group because of the way the colour is applied. It comes in several forms – soft, hard, oil (combined in sticks with fat and wax) or in pencils – which can all be used to create wonderful finished paintings as well as characterful studies. Soft pastels are particularly apt where a lot of blending is required and it is possible to create pictures with such subtle detailing that they look almost like oils.

### Mixed media

If one medium doesn't offer the scope of expression that an artist requires, he or she is free to combine several to take advantage of the good qualities of each. Oil is sometimes combined with oil pastels or oil bars while watercolour can be mixed with acrylic, inks (including acrylic inks), gouache and even poster paints. Ground pigments are also now available in specialist art shops and these can be mixed with anything from milk or egg yolks to gum Arabic, beeswax or oil to create customised paint. All sorts of fillers and mixers can also be added to paint including sand, plaster and texture gel to produce some wonderful textures and to this artists can add papers, either handpainted or printed, for collage effects. With so many exciting possibilities at their fingertips it is not surprising that a number of artists turn to mixed media for their work. Ultimately, of course, it is not which medium the artist chooses but what he or she does with it which counts.

# STILL LIFE WATERCOLOUR

Marjorie is a great collector of trinkets, kitchenware and other household objects found in antique shops and flea markets, 'being especially attracted to metal coffee pots, kettles and bowls', and she utilises her treasure in her paintings. She had recently bought the copper kettle featured in 'Still Life with Pomegranates' specifically for a commissioned work so when she decided to set herself a challenge with a highly complicated set-up, she thought of the kettle at once. The challenge was to include both fruit and flowers in the same painting since she had, until then, painted only one or the other, and she added a number of other materials – ceramic, fabric and metal – to make the challenge harder still.

**Still Life with Pomegranates by Marjorie Collins** watercolour on paper **55 x 72cm**

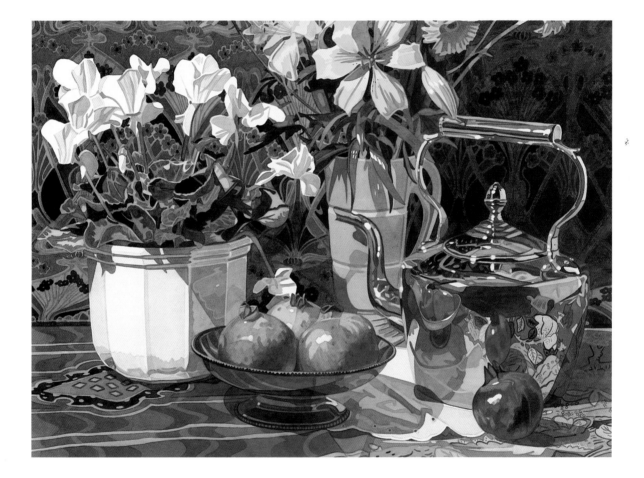

# Composition

**Still Life with Red Coffee Pot** watercolour on paper **46 x 56cm**
Here are Marjorie's original composition photographs for this painting. As you can see, she experiments quite a bit with her set-ups, even when they are made up of just a few elements, as here. In this case she has chosen the simplest arrangement with the elements creating a basic triangle. This simple geometric shape complements the pattern on the fabric and enhances the stark, minimalist colour combination.

Once Marjorie was fairly happy with the set-up, she got out her camera to see how the arrangement would look as a finished image. 'I always view the set-up through the viewfinder of my camera in order to explore various viewpoints and compositions. Often at this point one or more objects will have to be moved in order to obtain a better reflection or shadow in the foreground area.'

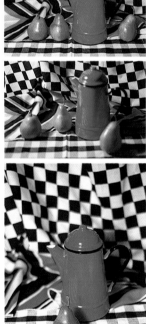

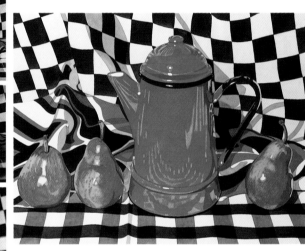

## Using photographs
Marjorie is one of the few artists who makes good use of photography for her paintings. She takes a number of pictures of the set-up from various angles and distances so that she can choose the best one or combine the elements of more than one in a single composition. Sometimes she will also rearrange the elements to see if she can improve the set-up. As you will see later, she uses slide film so that she can project the best image onto the surface of her watercolour paper when drawing, although she also refers to the original set-up items while she works.

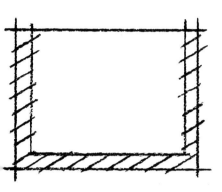

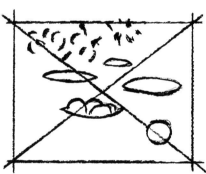

Marjorie has allowed a fairly equal border around the two sides and beneath the objects but crops the yellow bouquet off at the top. The space at the sides and bottom prevents the image from seeming overcrowded – cut off this space with your hands and you'll see how the image becomes too busy, with no restful spaces. Cropping off the flowers, however, is a good move because it adds drama and creates sweeping lines which lead us into the top corners of the painting. It also reduces large, unwanted background areas on each side of the flowers.

With a complicated set-up like this it is important to create a balance of form so that the 'weight' of the items is in perfect equilibrium. Here the items are balanced around a central point – the empty space above the bowl of pomegranates. The white ceramic cachepot containing the cyclamen is fat, its colour dense and opaque, so that it takes all the weight of the copper kettle, the vase of yellow flowers and a stray pomegranate to match it, particularly because part of the yellow flowers are cropped out to reduce their bulk. Mentally move that stray pomegranate to the other side, and see how the picture unbalances.

Notice the emphasis on soothing, rounded forms in this painting which help to make this a relaxing image despite its complexity. The bowl, jug, cachepot and kettle are all rounded, and even the lilies appear round when seen from front-on. Only the shell-shaped cyclamen flowers break the mould to offer a welcome change of form. They are still curvy, even voluptuously elegant, in keeping with the rounded forms elsewhere.

## golden rule

### Balancing forms

All items and even blank spaces have a visual weight which must be balanced to create a pleasing composition. Opaque, hot colours have a greater 'weight' than transparent, cool ones so a cadmium red boat can be balanced against a whole sea of manganese blue. For still life artists this means arranging and rearranging the items in the set-up until they look right or rebalancing the items in the painting by making colours stronger and more opaque or cooler and paler until equilibrium is reached.

# Colour

Marjorie's highly representational way of painting demands accuracy in the rendition of colour as well as form. 'I choose the objects for the set-up with an eye to their respective colours and how they relate to one another, so once they are in place I paint them as they are, without the need to enhance or mute. I do, however, have a tendency to prefer objects and fabrics that are brightly coloured and which contrast with one another.'

## The artist's palette

Marjorie used a palette of 14 Winsor & Newton colours for this painting: aureolin, new gamboge, yellow ochre, cadmium orange, burnt sienna, alizarin crimson, mauve, French ultramarine, cobalt blue, sap green, Hooker's green dark, Vandyke brown, sepia and lamp black. Black is an unusual choice because it can deaden colour, but Marjorie likes to tint it with French ultramarine for pattern detail. She also favours a mix of French ultramarine and mauve for shadows.

aureolin

burnt sienna

Vandyke brown

sepia

## pointer

### Black is back

Many artists and art teachers have dismissed black, saying that it dirties the other colours or simply isn't a colour at all. It is true that it is difficult to handle and can overwhelm a painting when used neat or heavily in mixes, but a little can be useful for muting and darkening other colours. It is also a highly traditional colour – probably the one first used by cave painters – and it has had great importance in Chinese art for thousands of years. More and more artists seem to be adopting it, and provided that you don't use it simply as a convenient way to produce any dark colour, there's no reason why you shouldn't try it too.

new gamboge

yellow ochre

cadmium orange

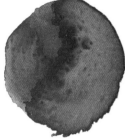

alizarin crimson

mauve

French ultramarine

cobalt blue

sap green

Hooker's green dark

new gamboge          alizarin crimson

lamp black

sap green

burnt sienna

sepia          cadmium orange

# Technique

'I start by projecting the chosen slide(s) of my set-up on to heavy cold pressed Not watercolour paper, correcting or changing the shapes of objects as I draw. While painting, I refer to the slide and have the actual objects in front of me, although not the original set-up. I replace deteriorating fruit and flowers as necessary.

'I paint all the shadows with a mixture of mauve and French ultramarine in order to establish tonal patterns. Then, working wet-on-dry, I glaze thin layers of local colour onto the background areas, starting at the back and then working forward until all the objects appear as negative shapes. Against this background I am better able to judge the correct colours of the main objects, so I continue by painting layers of local colour over each object in turn, being especially careful to paint around the white highlights of the white cachepot, the cyclamen flowers, pomegranates and kettle.

'I always paint an object, such as a single pomegranate first, before painting its reflection, in this case on the side of the copper kettle. Once all the reflections are painted, I analyse the remaining reflected shapes, changing them if necessary to make sure that they all make sense. Finally I check to make sure that the background recedes sufficiently. In this case I glazed in another shadow wash over the background area and intensified patterns in the fabric where necessary.'

## 'Paint only the differences between things.'
(Henri Matisse 1869–1954)

## shortcuts

### Starting with local colour
Local colour simply refers to the colour of an object – the exact yellow of a lily petal as seen in good light – but as all artists know, you'd be left with a very stylised image if you painted every petal on the lily and every part of every petal in the same colour. In real life each petal of that flower is seen as a multitude of hues and tones because of reflected colour, shadows and so on. Marjorie starts by applying a thin wash of each item's local colour, then builds it up from there, adding warm or cool layers of colour and introducing shadows and reflections as necessary. This is an excellent way of working, but remember to leave the lightest areas blank if necessary to prevent having to add highlights back in with Chinese white.

Even the background areas are rendered with great care and attention – this fabric is clearly recognisable as a Liberty print. To make sure that the pattern of the fabric did not compete with the main objects, Marjorie washed over it with a thin wash of Vandyke brown and her shadow mix of mauve and French ultramarine, toning it down and pushing it into the background.

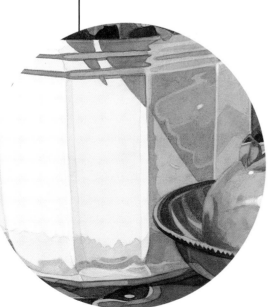

It can be very difficult to render white in a painting because it is important to give the object shape, but too heavy a hand with the washes will make it look grey. Marjorie has added her shadows with a restrained hand but made good use of some strong, dark shadows around the lip of the pot which help the white of the ceramic look whiter by comparison.

Marjorie renders the subject with great accuracy and we are rewarded with a visual treat, particularly with the intricate patterns and colours of the reflections. This is a time-consuming process, and a detailed painting like this usually takes Marjorie several weeks to complete.

# STILL LIFE WATERCOLOUR

When you look at this painting you are probably first struck by the wealth and depth of colour, but interestingly this was not something which really bothered the artist when selecting the flowers for the set-up. She was more concerned with arranging the blossoms in the vase in an inspiring way: 'I don't think about colour when I'm choosing the subject or working out the composition. The colour comes later.'

Carol does a lot of figure painting but she is a versatile artist and enjoys landscape and still life work as well. 'I find still life an appealing subject because it affords a way to make an interesting painting out of objects that are everyday, simple, overlooked or just plain ordinary. If you have a particular attachment to an object it is even better. You can begin to choose imagery that has an emotional connection to you or the viewer which can then carry a deeper message.'

**Spring Bounty by Carol Carter** watercolour on paper **152.5 x 101.5cm**

'Beauty in art is truth bathed in
an impression received from Nature.'

(Jean Baptiste Camille Corot 1796–1875)

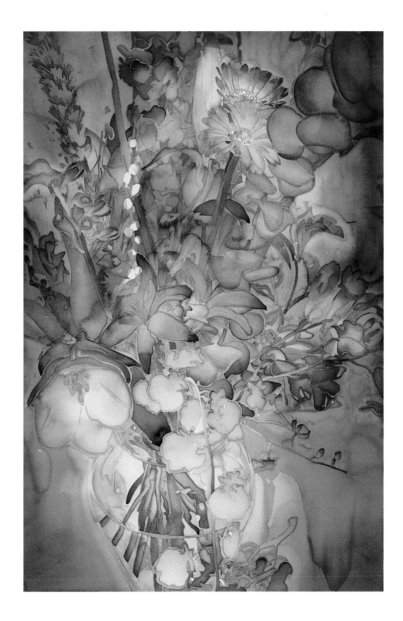

# Composition

Carol rarely does any preliminary sketches for a painting so most of the compositional work is done when arranging the items in the set-up. At this point Carol looks primarily at form and shape: 'I look for relationships between scale of flowers, stems and leaves and I seek variety of shape in the overall arrangement. I also strive for rhythms and flow, particularly in the foliage.' Look at the rhythms of the eucalyptus leaves on the right, for example. They seem to revolve around each other, echoing the shapes of the brightly coloured daisies beside them. These contrast strongly with the more aggressive rhythms of the sword-like leaves on the right.

## golden rule

**Dealing with the background**

When painting floral arrangements it is often a problem knowing what to do about the background. An elaborate background, such as an embroidered cloth, may take attention away from the flowers while a plain backdrop creates large dead areas. The space beside the vase can be especially problematic, particularly if the vase is tall and narrow. To get round this some artists add other objects to the set-up but Carol has found another solution by choosing a fairly short, fat vase in the first place, adding a few flowers around it and then cropping in on the floral display so tightly that she actually 'cuts off' some of the longer sprays, thereby reducing the area beside the vase to a minimum. She also paints the background in a fairly loose way to produce interesting colour variations which prevent this area looking dead.

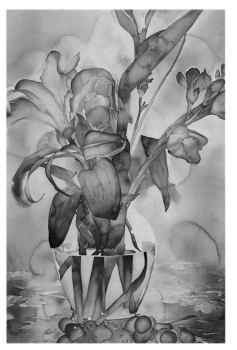

**King-size Floral** watercolour on paper **152.5 x 101.5cm**

Carol loves duality in her paintings so that the image seems to push and pull in different directions, leaving a certain sense of unease yet also creating an excitement. Here the arrangement is fairly simple and relatively limited in both shape and colour which you might expect to produce a calm mood. The bouquet is also fairly open which should enhance this feeling because there is no sense that the flowers are fighting for space. However, the use of complementary colours – orange and blue – is so powerful that it overrides the calm to inject tremendous energy. In this way colour and composition are in deliberate discord to disquiet us.

'I seek variety of shape in the overall arrangement. I also strive for rhythms and flow, particularly in the foliage.'

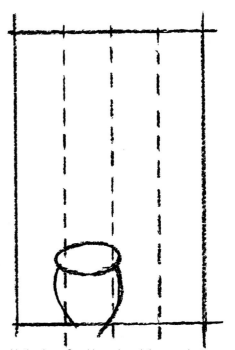

Carol zooms in on her subject, cropping off the vase at the bottom and the flowers at the edges so that they seem to burst forth from their confines. This, combined with the great size of the picture, produces an image of tremendous impact.

Our eyes usually look at the centre of an image first and if we find a focal point there it is somehow reassuring. Carol has placed the orange lilies here and they seem to leap out at us because of the contrast with the blue behind them. Wherever our eyes rove they always return here.

Notice how Carol has placed the vase just slightly off-centre. It is neither in the middle nor in one of the other traditional positions roughly a third or two thirds of the way across the support. Being unexpected, this produces a sense of unease – it is almost as if we feel the need to reach into the painting and move the vase.

# Colour

Carol loves vibrant, saturated colours for both their seductive and confrontational qualities. She uses only Winsor & Newton artists' quality paints because they are capable of creating the depth of colour she requires. Notice the clarity and transparency of the colours she has chosen which make the paintings look as if they have been worked on silk or painted on glass. This is partly achieved by using many of the colours unmixed so that their true qualities shine through.

### The artist's palette

Carol needed a large palette of paints to capture the rainbow of colour she saw in the petals and leaves of the bouquet in 'Spring Bounty'. Her palette included two yellows: aureolin (also sometimes sold as cobalt yellow) which is a bright, strong, clear, transparent yellow and Indian yellow which is softer and browner but still clear and transparent. She also used Prussian blue, a colour so strong that many artists are afraid to use it, but its depth, transparency and vibrancy make it a perfect addition to Carol's strong palette. Another interesting colour she chooses is Winsor violet, a rich, transparent colour which, like Prussian blue, is staining. Already you will begin to see the qualities she seeks in her paints – strong, clear and transparent. Indeed only cobalt turquoise and cadmium orange from among the 11 on her palette are opaque and more than half the colours are classed as staining.

## pointer

### Complementary colours

Complementary colours are those colours directly opposite each other on the colour wheel which, when laid side by side, increase each other's power and intensity. Thus orange placed next to blue or red next to green seem almost to sizzle and vibrate. Carol makes heavy use of complementary colours so that her paintings 'sing'. For example, the orange and blue totally dominate 'King-size Floral', each making the other brighter and stronger. She also uses near-complementaries such as yellow and blue which intensify each other but not to quite the same extent as using true complementaries – yellow and violet, for example.

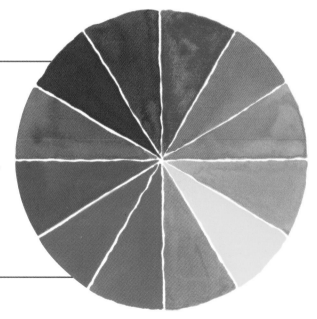

aureolin

Indian yellow

cadmium orange

Winsor red

alizarin crimson

burnt sienna

French ultramarine

Prussian blue

cobalt turquoise

Winsor green

Winsor violet

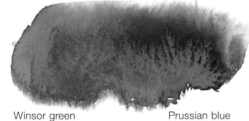

Winsor green          Prussian blue

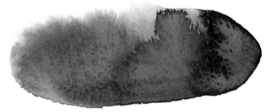

Winsor violet          cadmium orange

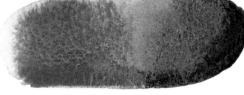

French ultramarine          burnt sienna

# Technique

Carol uses huge sheets of paper and generous pools of colour so she finds it easiest to work on the floor where she can allow the washes to 'puddle'. Most watercolour artists lay in the colours gradually, overlaying washes stage by stage until they eventually build up the required depth of tone. Carol works in her own way. Once she has plotted the forms of the set-up in pencil she starts by painting the background. 'After the background is dried I begin to paint in the subject, starting with the forms which are farthest away – in this case the leaves. I then work forward in the picture plane, finally ending up by painting the vase.' This is interesting because it is a method sometimes adopted by landscape artists. By starting with pale, bluish washes in the background and working forward with thicker, hotter colours, they are able to recreate the effects of aerial perspective so that distant objects stand back from the subject matter in the foreground. As you can see, it is a technique which also works extraordinarily well with floral still life arrangements.

Carol takes two to four days to complete a painting like this, working for a full eight hours each day. 'I typically work when it's raining so that the watercolour washes dry slowly and I am able to manipulate them with intense colour and clear water to make them look rich, fluid and spontaneous. I do not work in dry weather.'

## Recreating the effects of aerial perspective

Aerial perspective is something most often associated with landscapes but it is still relevant to other subjects, even still lives. You can see it most obviously in a landscape or seascape where forms become bluer and greyer the farther they are away. This is due to the veiling effect produced by all the tiny particles of dust and water in the air and it obviously becomes much more apparent when a mist or fog descends. Colours seen through these veils are also muted – a scarlet flag on a ship will look much duller if the ship is a few kilometres away than it will if it is moored alongside you.

Going further than a simple figurative reproduction of the flowers in front of her, Carol turns the image into a statement about colour and form, yet we can still see where she is coming from and that this is quite clearly a vase of flowers. Notice that she has created the effect of aerial perspective by blurring, lightening and tingeing the foliage at the back with blue to push it behind the main display (see Shortcuts).

Notice the size of Carol's painting. Working large enables her to get 'right inside' the floral group and even 'enter' individual flowers to capture details without having to fiddle – working too small would encourage her to become too figurative and that would lose all the freshness and spontaneity of the work.

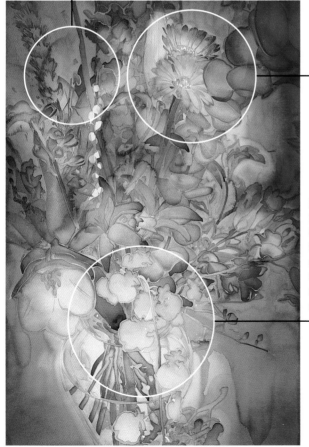

Here you can see how important form is to Carol. She hasn't made any attempt to mould the flowers because she is more interested in their overall shape and their contribution to the composition as a whole.

# STILL LIFE OILS

Gail is an artist whose main interest is in the pattern-making qualities of an image. She often chooses items from around the home and arranges them in a way which brings this element to the fore. 'I have an interest in familiar decorative domestic objects – either mine or borrowed from other people – arranged in ways that create intrinsic patterns. The main inspiration for all my paintings is the colour: I start with a strong idea for a particular combination and I select objects around this.'

Still life is ideal for Gail's style because it gives her control over the subject and its arrangement, but, 'the drawback is that because the set-up can remain, unchanging, for as long as you choose there is a temptation to overwork the painting'.

**Yellow Daisies by Gail Brodholt** oil on board **56 x 56cm**

## 'The main inspiration for all my paintings is the colour.'

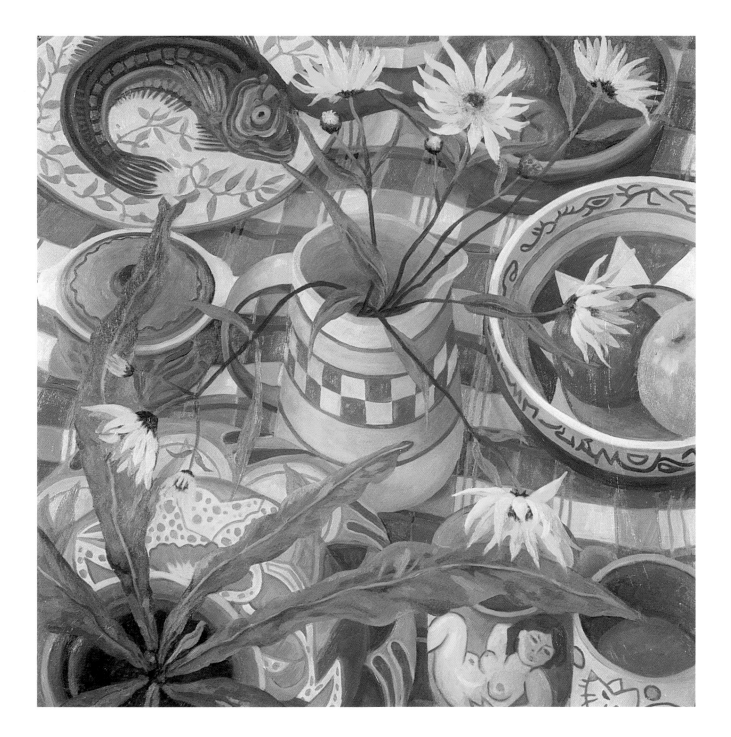

# Composition

'I usually start by making a rough drawing of the composition in my sketchbook and then transfer it onto the board. The arrangement can change quite a lot as I add some objects and take others away, so it is important that I am able to scrape the surface down with a palette knife or, if I am changing it radically, to sand it down. For this reason I like to paint on medium-density fibreboard.

'Sometimes I trim the painting – by no more than a few centimetres – because I like to change the shape of it once I've started. I like to keep a sense of other things going on outside the parameters of the picture so I often use sharp angles and cut the objects off at the edges.'

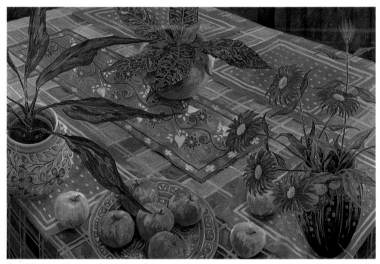

**Red Table** oil on board **61 x 91cm**
Notice the high perspective here which Gail also adopted for 'Yellow Daisies'. Gail finds that this helps to emphasise the patterns made by the arrangement of objects in her still lives. The inclusion of many decorative items, such as the patterned cloth and ornate vases heightens the pattern-making element of this painting even further.

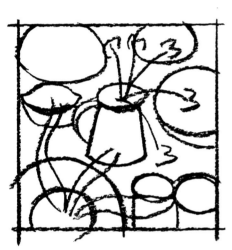

Gail deliberately crowds the painting with objects to increase the pattern-making quality of the image. The sheer number of objects makes our eyes rush all over the support, giving the painting a sense of urgency and excitement which is heightened by the bright palette of colours.

'The negative spaces are just as important to me in a painting because they add to the overall pattern.' These are the spaces around and between the objects, here represented by the tablecloth which is in itself highly decorative. Look at the negative spaces. If they were even throughout then the set-up would look too contrived, but Gail has managed to balance them so there are no large areas which would distract the eye.

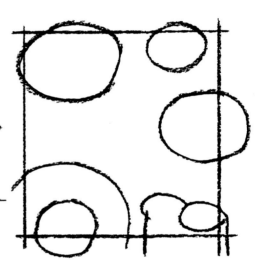

Most of the objects around the perimeter have been cropped by the edges of the support, pointing to the world existing beyond its confines and encouraging the more imaginative among us to dream up the rest of the setting.

## golden rule

### Cropping objects

Cropping an object in a painting does several things. Gail crops her subjects to hint at the realm beyond the support, but it can also be used to add intimacy by seeming to zoom in on the subject(s). Alternatively it can create huge impact as if the subject was about to leap out of the painting at the viewer. Impressionist Edgar Degas (1834–1917) used it to suggest life and movement, cropping off parts of his models to give the impression that they were caught in a snapshot in a frozen moment of life and time. It was the development of photography at this time which inspired him to compose his paintings in this way.

# Colour

All Gail's paintings are bright and lively with extensive use of fully saturated colours. Usually there is a leaning towards a specific hue such as yellow or red. 'I like to establish a specific colour key in a picture [see Pointer]. To achieve a strong colour bias I often add some of the dominant colour to the other colours within the painting when the objects themselves do not correspond to the key. My choice of colour is influenced by the time of year: "Yellow Daisies" was painted in the autumn. In the colder months I tend to paint darker, richer paintings, while in spring and summer I am drawn to lighter colours.'

### The artist's palette

'My palette is always the same – French ultramarine, burnt sienna, cadmium red, permanent rose, cadmium yellow, lemon yellow and titanium white. I don't use black but I find that a mixture of French ultramarine and burnt sienna makes a very powerful dark. I rarely use pure white straight on the painting because I think it looks too harsh.'

### Pink Still Life oil on board 61 x 61cm

This painting was produced in early summer when Gail was drawn to lighter colours, hence the slight bias towards pastel hues. However, the colour key is still quite high.

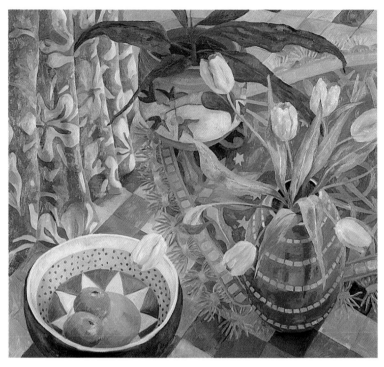

'It is the eye of ignorance that assigns a fixed and unchangeable colour to every object.'
(Paul Gauguin 1848–1903)

lemon yellow

cadmium yellow

cadmium red

permanent rose

French ultramarine

burnt sienna

lemon yellow          permanent rose

burnt sienna          French ultramarine

cadmium yellow          French ultramarine

# pointer

## Colour key

The colour key basically refers to the range of colours an artist uses. A high colour key indicates a palette of intense, bright colours, while a low colour key would point to a range of subdued neutrals. Gail loves intense yellows, reds, greens and blues so even in the summer when she is drawn to a cooler palette her colours are still joyful and vibrant. Notice that when all the colours belong to the same group they create harmony and balance, but when one or two stand out they strike a new note which can either be a stroke of genius or a disaster.

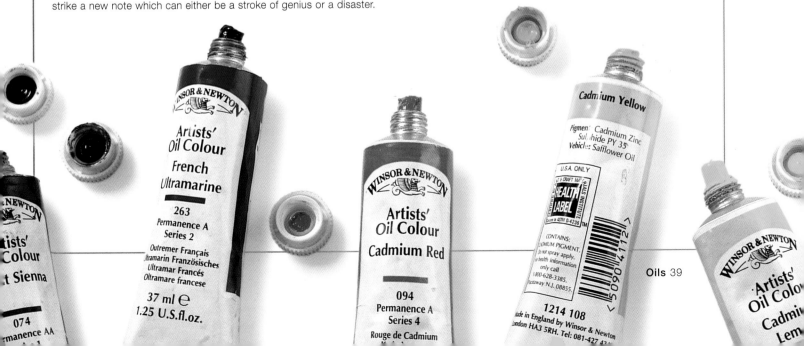

# Technique

'I start a set-up by selecting more objects than I need, but all related to a greater or lesser degree to the colour scheme I have in my head. Then I spend the first day arranging them. At the end of that day I make a rough pencil sketch to check that the composition is balanced and then I don't refer to the sketch again. I have found that if I plan too much the painting can look dead so I don't like to have it all worked out before I begin.

'I paint on medium-density fibreboard (MDF) primed with acrylic gesso because it is rigid and smooth. I draw the composition roughly on the board first. When I begin painting I dilute the paint with a little turps but as the painting progresses I use the paint straight. I don't use any other mediums. I work layer on layer and change the objects as I go so my paintings are quite time-consuming – "Yellow Daisies" took about four weeks painting every day.'

## shortcuts

### Caring for brushes and paints

Gail doesn't buy expensive brushes because she says she goes through them at an incredible rate, 'probably because they spend all their working lives sitting in a jar of dirty turps'. This is all too common. After all, not many oil painters want to spend time cleaning their brushes when they could be painting, especially when the cleaning process often covers hands and clothing in paint. However, it is worth caring for your tools and materials, particularly if you are only an occasional painter since paint allowed to dry is terribly difficult to remove. Ideally dip the brushes in turpentine and then wipe the paint off on a clean rag after a painting session. Wipe paint from the neck of the paint tubes too, otherwise you'll never get the lids off again.

Working in many layers enables Gail to build up wonderful colour depth. Combined with her high colour key this creates paintings which are rich and vibrant with tremendous luminosity.

Gail often crops her subjects at the edge to make the viewer more aware of the world beyond the confines of the support.

Gail doesn't like to use neat white in her paintings because she finds it too harsh, so highlights are soft and discreet. This helps to ensure that it is the pattern-making quality of the image as a whole which stands out rather than the forms of individual objects.

# STILL LIFE OILS

'Still life appeals to me because it incorporates all the problems of painting and drawing in a simple format which is easy and inexpensive for anyone to approach. This is why it is central to my teaching practice. It also makes a refreshing change for me to work from life because the bulk of my work is influenced by various theatrical residencies and grows out of the imagination. Still life work also influences my perception of my other studio work which I find to be of great benefit.

'In this particular case I was looking for a simple idea that extended the pictorial possibilities of the still life. The use of a mirror provided the means to the end I was looking for – it amplifies the subject by creating a different viewpoint and by providing fresh patterns, repetitions and so on.'

**Daffodils and Yellow Background by Gerard Tunney** oil on canvas **30 x 41cm**

'Painters like Cézanne, Morandi and Chardin used the simplicity of the still life to create something permanent and concentrated which I much admire.'

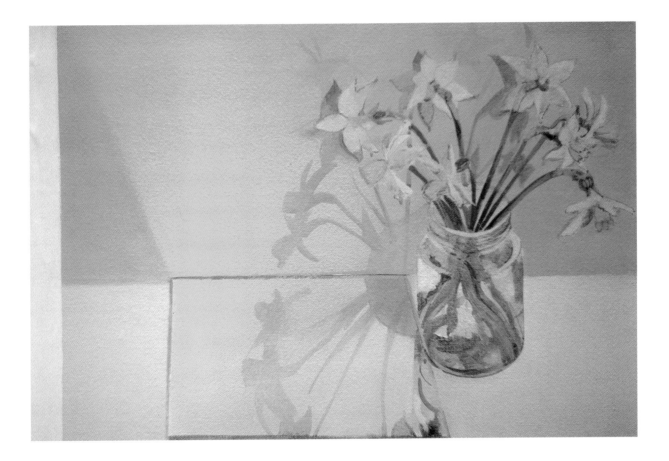

# Composition

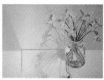

The arrangement of still life objects is where composition begins and like all artists Gerard takes some time over this stage. For this set-up he arranged the flowers in a jar of water and placed them beside the mirror, then slotted a sheet of mounting card behind them as a backdrop. 'There followed a process of arrangement and rearrangement until the qualities I wanted were most effectively highlighted. I was looking for contrasts with parts sharply in focus, others diffused as reflections, the actual definition of the subject set against the abstract patterns in the mirror. I also wanted to play off the contrast between the three-dimensional flowers and their two-dimensional reflections, all placed together in a two-dimensional painting.

   'A small rectangular viewfinder made from card helped me visualise what the finished arrangement would look like on canvas. I tried to keep it as simple and uncluttered as I could so that the space surrounding the still life contributed to an overall balance.'

**Pansies and Red Background** oil on canvas **30 x 41cm**
Here Gerard re-examined the idea of flowers and reflections, this time placing the jar of flowers on top of the mirror. Now the mirror has less importance than in 'Daffodils and Yellow Background', being there simply to reflect colours, light and the shapes of the flowers.

## golden rule

### Using a viewfinder
A viewfinder is simply a piece of card with a rectangular window cut out of it which artists can use to look at their subject and see it as it will look on the support. A camera can be used in exactly same way, but the advantage of a viewfinder is that the window can be cut to the same proportions as the support to give a true idea of how the composition will work. If desired, thread can be stuck to the viewfinder in the form of a grid. When a similar grid is sketched onto the support, the grid on the viewfinder will act as an aid to accurate positioning.

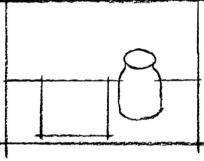

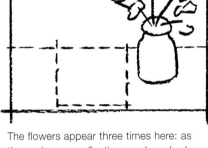

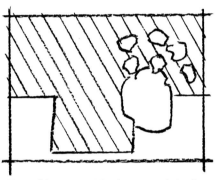

By placing the mirror fairly centrally in the picture Gerard gives it special importance. This is heightened by the fact that the mirror reflects the yellow background, this bright colour making it much more noticeable.

The flowers appear three times here: as themselves, as reflections and as shadows on the yellow background. This enables Gerard to play with pattern in a visual way and also to express a transcendental meaning – is a shadow or reflection as real as the object itself and do we ever actually see the real object or experience real life?

The striking geometric shapes made by the background, the mirror and the light reflecting from it back onto the background produce a bold and powerful statement. This is softened by the rounded form of the jar, the slightly curving stems and elegant curves of the flower heads.

'To generalise is to be an idiot. To particularise is alone distinction of merit.'
(William Blake 1757–1827)

# Colour

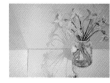

'The temptation with such a simple subject is to embroider it, making the colours more vivid and emotional. However, this series of still lives was devised as a painting exercise based on direct observation, so it was necessary to try to interpret the subject within the framework of what could be seen and any invention was very limited.'

Gerard starts with an underpainting worked in acrylic and then paints over it with oils. It is a technique akin to that used by Renaissance painters who often started with tempera (a medium which combines water and egg) and then applied oil glazes on top to increase the richness and depth of colour. Gerard's palette of acrylic colours is very similar to that of the oil colours.

As well as examining different arrangements with flowers and a mirror, Gerard used this series of paintings to explore different colour themes. Take 'Pansies and Red Background', oil on canvas, 30 x 41cm, right. Here the large expanse of green background gives this painting a mellower mood than that created by the bright yellow in 'Daffodils and Yellow Background'. This is enhanced by the strong horizontal line where background and mirror meet which also produces a calm feel.

## The artist's palette

The first layers of paint were applied with Winsor & Newton Finity acrylics. Gerard used titanium white, ultramarine, lemon yellow, cadmium yellow medium, cerulean blue hue, permanent alizarin crimson, cadmium red medium and phthalo green blue shade. Over this he applied Daler-Rowney oils, mixing them with Winsor & Newton Liquin medium to speed the drying. He used titanium white, lemon yellow, cadmium yellow hue, vermilion hue, cadmium red deep hue, alizarin crimson, French ultramarine, cerulean blue hue and viridian hue.

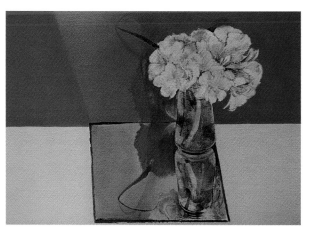

'The temptation with such a simple subject is to embroider it, making the colours more vivid and emotional.'

lemon yellow  cadmium yellow hue

lemon yellow

cadmium yellow hue

cerulean blue hue  viridian hue

cadmium red deep hue

alizarin crimson

vermilion hue

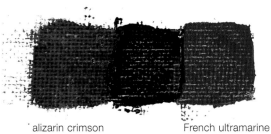

alizarin crimson  French ultramarine

cerulean blue hue

French ultramarine

viridian hue

# Technique

'Each painting in this series was completed over a four or five day period, so it was important that my viewpoint remained consistent. I made a note of where I stood in relation to the easel and the still life and this position was maintained during the work's progress.

'I started by mapping out the proportions and scale of the set-up in acrylics, applying the paint with a combination of brush and knife to create a thick impasto. Being water-based, acrylic dries quickly so corrections can be rapidly made which helps give the work flow and momentum. Flowers tend to droop and change position as they wither, so I put them in first, working on the background later and not touching the flowers again until the final oil glazes. I find that the textured underpainting lends itself to a succession of washes as the surface is gradually built up.'

At this stage all the main elements of the painting are completed – the colour balance and positionings are established and tonal values are confirmed. 'Only then do I apply the oil glazes which go on very thinly. Their role is simply to enrich the existing colours, although I do sometimes add accents at this stage. Two to three days drying time is needed between each glazing session.'

## shortcuts

### Marking your position

If you are seated to paint a still life then it is relatively easy to maintain a fixed position from session to session, but if you prefer to stand at an easel, as Gerard does, then this becomes more difficult. Even a slight change of position can have a major effect on the positioning of the elements in the painting, and if you don't notice at once then it can have a disastrous effect on the draughtsmanship of the painting. One trick practised by professionals is to put masking tape on the floor where their toes go. These act like a runner's starting blocks to provide a fixed position for the feet. This technique can also be adopted to mark the position of the easel if it isn't practical to keep it in position from day to day.

All the texture in the finished piece is applied in the early stages of the painting process when Gerard paints enthusiastically in acrylics. He describes this as impasto – i.e. thick – but it is all relative and by some artists' standards this would still be quite thin.

Notice how Gerard differentiates between the flowers as reflected in the mirror and as shadows on the background. While the edges of the reflections are soft and watery, those of the shadows are crisp and hard.

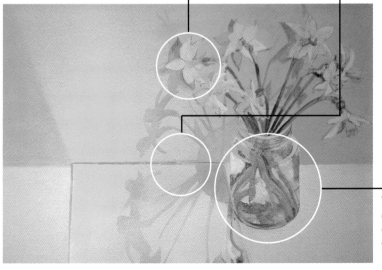

The water distorts the shapes of the flower stems, giving Gerard the chance to explore yet another reality.

'As an artist I am inspired more than anything else by life itself. The brushes have to be connected to the soul; only then will the small and insignificant thing that I paint reveal its beauty. This beauty can be found equally in royal garments or in a peasant's clothes – for me there is no difference.

'I decide on my still life set-ups according to the mood I am in. My pictures are quite different to each other because my mood is constantly changing and I am always searching for a certain feeling. For example, in "Pot and String of Garlic" I wanted to capture the peaceful feeling of the set-up and transmit it through my painting to the viewer every time he or she looks at it. I also wanted to explore the power of simplicity in this painting and as a result I was quite satisfied with the finished piece, which is very unusual for me.

'I enjoy painting still lives because it enables me to paint many different materials and textures and experiment with the various effects of light. It is also a situation in which I can work in "silence" in a certain way, because it can be very complicated when I am working with models to keep an emotional balance. However, I feel that if an artist only paints still lives all his life he is limiting himself by expressing only some of his feelings. Painting a landscape or figure gives you the possibility to say something more.'

Kitchen Table by Adam Katsoukis oil on canvas 30 x 40.5cm
Pot with String of Garlic by Adam Katsoukis oil on canvas 40.5 x 36cm

'I feel that if an artist only paints still lives all his life he is limiting himself by expressing only some of his feelings.'

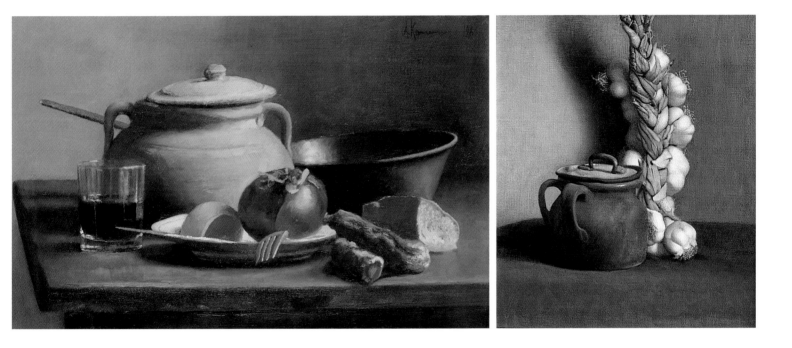

# Composition

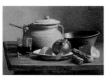

'I compose my paintings by studying the light that falls like a veil, giving form and revealing the hidden atmosphere. Colour and shape come after that, and light remains the most important element in my compositions. I always work from life and never use any photographic references. I will take the objects and place them somewhere and then start moving them around until I find the balance, harmony and feeling I am looking for.'

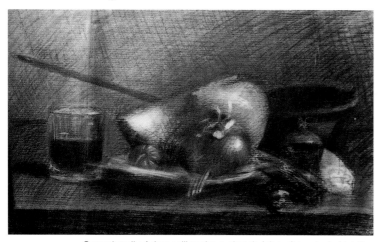

Occasionally Adam will make a sketch (above) or study (right) before embarking on a painting but generally he starts work straightaway on the canvas.

### Painting light

Light is what gives objects their form – without it we would literally see nothing. It is the way that light hits an object that reveals whether it is curved or straight, raised or flat, and it is even what gives it a colour. Some artists arrange their still lives according to colour, some according to form, but Adam takes perhaps the most important factor of all in the visual arts – light – and arranges his compositions around it. He generally prefers a cold North light which complements the muted colours he loves. Sometimes he will make sketches to study how the light works in the composition, or he might even do a finished drawing, but usually he sets to work straightaway on the canvas.

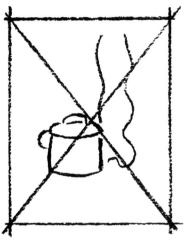

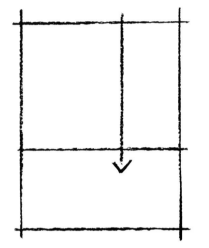

The exact centre of a painting is a very important place compositionally, and artists will often place a focal point here. In this painting it is the place where the pot and string of garlic meet which helps to give the image great strength and stability.

Horizontal and vertical lines in a composition are very calm, even static. This makes them ideal where the artist wishes to create a highly peaceful mood, as here. In this case the garlic string and the back of the table form very strong vertical and horizontal lines.

Counterbalancing the static mood set by the vertical and horizontal lines in this composition are the voluptuous curves of the garlic bulbs and the rounded forms of the pot with its oval lid and crescent handles.

## golden rule

### Creating a peaceful mood

Adam has used most of the techniques available to the artist for creating a peaceful mood in 'Pot with String of Garlic'. As mentioned above, he has used two strong vertical and horizontal lines which help to reduce the sense of movement. These bisect the edges of the support, giving them even more strength. He anchors the image further by placing the objects in the middle of the support so they meet in the centre. Additionally he uses a very neutral palette of browns, greys, black and white which is much more calming than punchy primary colours. Another option available to the artist to create calm is to produce a highly symmetrical image. However, if you use too many of these devices in one painting it can become too static.

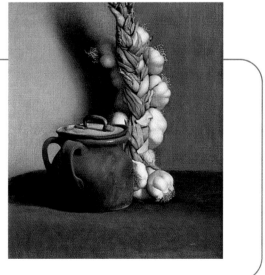

# Colour

Adam prefers to mix his own colours as far as possible, rather than buying a large range of ready-made hues: 'My basic palette is very limited, comprising the three primary colours, blue, red and yellow plus white. I will usually mix these to get the exact hue that I want. I am very fond of the brown-grey tones and avoid using any pre-mixed versions.'

This method of using a limited palette is very good practice, particularly for beginners since it enables the artist to get to know his colours thoroughly. Using a pre-mixed colour may seem like a shortcut, but in the end you will learn little about good colour mixing. In addition a large number of pre-mixed colours rarely work harmoniously in one painting and create jarring notes. The Great Masters of the past did not have the luxury of being able to pop out to the shops for a new tube of paint, and since their colours had to be mixed laboriously, they did not tend to use many, yet their works have enduring appeal.

French ultramarine          chrome yellow deep

raw umber          vermilion extra

transparent red oxide     yellow ochre

# 'My basic palette is very limited, comprising the three primary colours, blue, red and yellow plus white.'

### The artist's palette

In 'Kitchen Table' Adam used lead white, two yellows (chrome yellow deep and yellow ochre), three reds (transparent red oxide, vermilion extra and alizarin crimson) and one blue (French ultramarine). He also used raw umber to obtain the rich dark browns that were needed. Notice that this is quite a muted palette with the two earth colours yellow ochre and raw umber helping to soften the other colours in mixes. One of his reds, transparent red oxide, is also very muted and is in fact often classed as a brown. This leaves chrome yellow deep, French ultramarine, vermilion extra and alizarin crimson to provide the fully saturated colour in the painting, a very modest selection by any artist's standards, but certainly capable of providing a wealth of intense hues.

chrome yellow deep

yellow ochre

vermilion extra

transparent red oxide

French ultramarine

raw umber

alizarin crimson

## pointer

### About chrome yellow

This colour was used extensively by Vincent Van Gogh (1853–90) in his famous 'Sunflowers' painting. It is a fairly strong lemon yellow with good covering power but unfortunately it tends to darken and dull down as an oil colour. This occurs whether the paint is used on its own or in a mix, so if this doesn't suit the mood of your painting use a permanent colour such as cadmium lemon. Note that some manufacturers sell other pigments under this name which may be more reliable.

# Technique

'I work in a very traditional way but at the same time I develop my own technique as I go. I use only natural light, mostly coming from the North and paint on linen canvas primed with gesso or oil colour, sometimes preparing these materials myself following old recipes.

'To start with I apply a coat of a brownish tint all over the canvas and when this is dry I make a wash drawing with dilute raw umber, sketching in the main shapes to "find" the position of each item in the picture. I paint on top of this, placing particular importance on finding the correct tone and value and laying colours next to each other like a mosaic. I work over this once it is dry, refining, layer upon layer, until I produce the desired effect. Shadows are ethereal and fine as vapour, while lights are thick impasto. I don't much like working wet-in-wet, so I often use a medium to speed up the drying times. Even so the average painting takes ten to 15 days to complete.'

'The eye must be taught to look at nature; and how many have never seen and will never see it!'

(Jean-Baptiste Siméon Chardin 1699–1779)

## shortcuts

**Making your own gesso**

Although gesso is widely available ready-made, Adam sometimes makes his own, perhaps because like many artists he finds the idea of seeing his work through from start to finish very appealing. Gesso can be made by mixing equal quantities of whiting and glue size. First dilute one part of size with eight parts of water and heat gently, then add some of this, little by little, to the whiting, mixing thoroughly until it has the thickness of smooth cream. As you work do not to let too much air get into the mix. Apply the gesso to board or canvas-covered board, working quickly and trying not to go back over an area once covered. Once dry apply the next coat at right angles and repeat until the desired finish is achieved. Lightly sand the final coat and dust off. Do not apply gesso to loose canvas because it will crack.

By closely studying the way the light catches his subject Adam is able to give objects a highly realistic three-dimensional quality so that it seems as if we could reach out and pick up one of these sausages for our lunch.

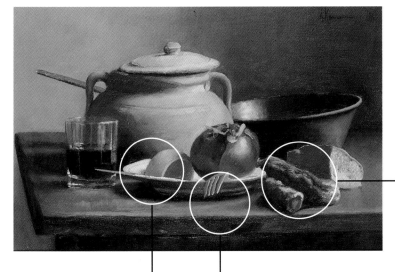

Shadow colours comprise thin veils of paint which create a smooth surface that suggests unknown depths.

Adam applies his highlights with thick paint in the final stages of the painting. This not only ensures that the colour is true since the paint underneath will not show through but it also guarantees that the highlights will reflect more light since they stand proud of the support.

# STILL LIFE OILS

Martin is an artist who finds the colour, shape and texture of objects interesting and is even fascinated by the most unlikely subjects. 'Although I often use household objects in my still life paintings the majority of motifs are of dead birds and insects which I have found while out walking. I put my find on a smooth, light surface and turn it around, trying out several different positions and vantage points. Many potential ideas for paintings go no further than this stage if I cannot imagine the object translated onto canvas in a particularly clear and balanced way. If I can visualise it then I think this is where the real inspiration starts.

'The advantage of painting dead creatures is that they don't run away and one has plenty of time to move them around and see how they are put together by the shaping hand of evolution. Insects have an advantage over, say, birds because they don't visibly decompose as in effect their skeletons are on the outside and one can get really close without having to wear a mask. The disadvantages are that it is not always clear to the naked eye what is going on – where the legs and wings join the body, for example. If I have to resort to a magnifying glass I try to minimise its use because it puts a great strain on the eyes. Another drawback is that as a painter of dead animals, and a nature lover at the same time, I refuse to go out like the natural history illustrators of the 18th and 19th centuries and shoot a few specimens. I have to wait for what chance throws dead in my path and when it does, anything that is reasonably intact is eagerly scooped up for consideration.'

**Bee by Martin Huxter** oil on canvas **40 x 40cm**

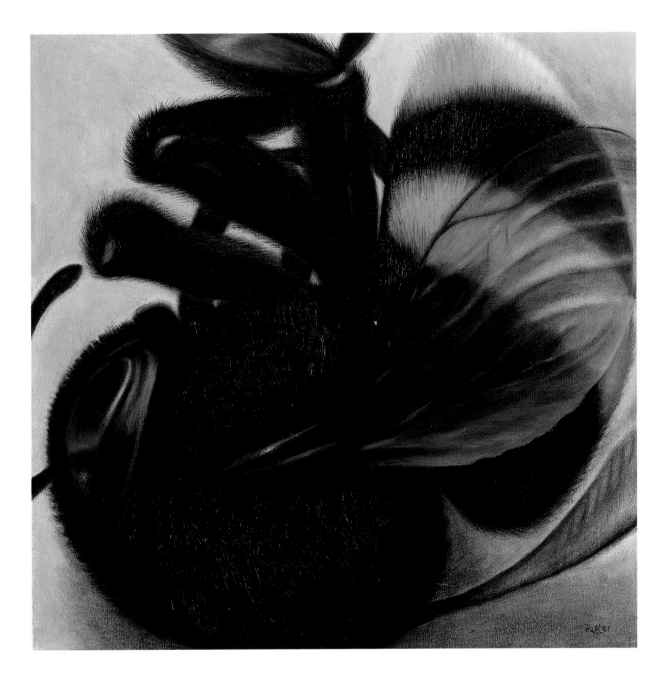

# Composition

The insects and animals which Martin draws are not just objects – they are the bodies of living creatures which is something that he wants to get across in his work. He considers every creature as an individual. Of the bee he says, 'bumble bees don't really look like insects but like something you might find lying about in a play-pen. They lack the superficial fierceness of other insects and often look quite friendly. I often find dying bees bearing no sign of injury which are in all probability just worn out by the constant search for nectar and the management of the hive. For these reasons there is something quite poignant about a dead bee and I wanted this to be apparent in the painting.

'I decided that the rounded foetal position was important and soon realised that it was not necessary to show the end of legs, wings and antennae which could be cropped out, allowing for a greater sense of closeness. I was left with a fairly circular main shape pressing against the edges and happily quite a balanced composition. The background is not so important for me and I often reduce the number of elements to just a single motif. I am more interested in the relationship between the motif and the edge rather than the relationship of different objects.'

**Three Garlic Bulbs** oil on canvas **50 x 130cm**

Here, again, Martin has chosen the size of the support to suit his subject. It seemed to him that three bulbs made a more interesting painting than one and that therefore this short, wide format was most suitable. The three bulbs are not grouped but arranged side by side, and the absence of distracting shadows allows us to compare them and begin to notice the subtle differences in shape and in the texture and patterning of the skins.

'I think every image has an optimum size. The painting must be big enough to be seen clearly from a certain distance and to work as an object without resorting to gratuitous exaggeration of size.'

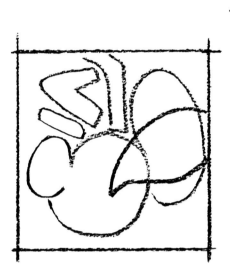

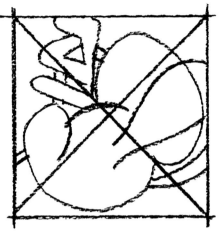

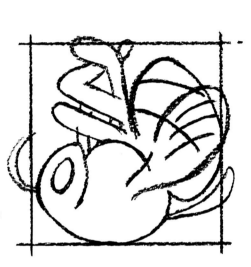

By cropping off the legs, antennae and wing tips Martin is able to create a greater sense of intimacy. This is emphasised by the bee's foetal position which makes it look approachable, so we feel we could almost reach in and stroke it.

Martin chose a square format because it fits the bee perfectly to emphasise the curve of its back and the sweep of its head. It is almost as if the bee is pressing against the edges of its confines like a living bee in a box.

The closeness of the image enables us to study the intricacies of the bee and we are made aware of the variety of pleasing, rounded shapes which go into the making of the insect.

## golden rule

### Square formats

The majority of artists work on a rectangular support which is the shape of most ready-made canvases and boards. Generally the support is used on its side for a landscape and vertically for a portrait while still life artists simply turn it whichever way suits their subject. However, non-standard formats can be much more eye-catching, and for artists who stretch their own canvas or who work on board which they have cut to shape it is not difficult to experiment with other formats. The square format is particularly attractive because it has a stability which is appealing to the eye and it also reminds us that this is art and not simply an imitation of Nature.

# Colour

Martin uses paints from a number of different manufacturers including Schminke, Rowney, Old Holland and Talens Rembrandt because, 'the colours and consistencies vary from brand to brand and with experience one can choose which is best suited to a particular desired effect'. Unlike many artists, he hardly ever uses the same palette of colours twice. 'After I have made a preliminary drawing and scaled it up to the canvas size, I then choose the colours carefully which can take several hours.'

### The artist's palette

For 'Bee' Martin used Winsor & Newton artists' quality colours in cadmium yellow, cadmium red, alizarin crimson, viridian, ultramarine, raw sienna, lead white and zinc white. Notice the lack of black paint – many artists prefer to mix their own blacks because it creates greater depth and a hint of colour. 'The bee seemed to be almost completely covered in jet-black "fur" but I decided to use a mixture of alizarin crimson and viridian which gives a lovely glossy, mauvey black. Greys mixed with it are much nicer than the rather dead greys obtained from lamp or ivory black.'

## pointer

### Types of white

There are three main artists' whites: flake white (also called lead white), zinc white and titanium white. Flake white is one of the earliest manufactured pigments on record and is regarded by many as the best. It is opaque and dries quickly to a tough but flexible finish. Its buttery texture also makes it a delight to use. It is, however, highly toxic which puts many people off using it, but provided you take precautions it is fine – don't eat it, smoke while using it, allow it to get into any cuts or leave it on your skin for too long. Zinc white is the most transparent white. It is cold and strong. It is not recommended as a base colour because it can crack and is slow to dry. Martin used it in his painting, 'because it is the most transparent white and therefore good for the smoky glaze on the wing'. The final white, titanium, is the strongest, purest white of the three and the most opaque, making it a good choice for overpainting. Its strength means that little is needed because it quickly influences other colours and it is inexpensive, making it a popular paint.

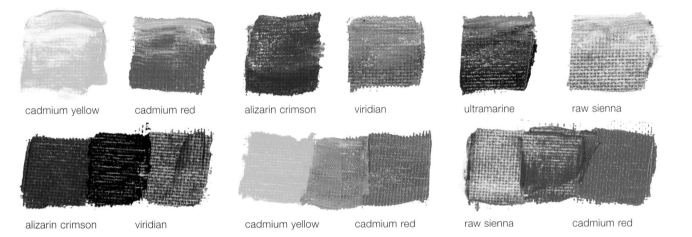

cadmium yellow     cadmium red     alizarin crimson     viridian     ultramarine     raw sienna

alizarin crimson     viridian     cadmium yellow     cadmium red     raw sienna     cadmium red

'The ideal artist is he who knows everything, feels everything, experiences everything, and retains his experience in a spirit of wonder and feeds upon it with creative lust.'
(George Bellows 1882–1925)

# Technique

'I find that I usually have to adapt my technique for each painting although I have evolved a generally slow, methodical technique and I tend to try to finish one area before I go on to the next (usually adjacent) area. This is very different from how I started painting, keeping all areas on the go at the same time and adjusting the composition as I went along. This is now all decided in preliminary drawings and allows me to use extensive underpainting which has its own effect on the final layers. In many paintings, including "Bee", I like to let the warm underpainting come through, so I am careful to put the top layers on in a "dragged" way which does not completely obliterate what lies beneath. This is especially apparent in the blue background.

'For "Bee" I did a lot of underpainting on the areas of "fur" where I used fairly stiff lead white mixed with a warmish brown and whipped up little crests and furrows with a worn bristle brush to try to get the feeling of the "fur" and the way it was lying. When this was dry I put a more oily layer of blackish mixture over the top. This was just thick enough to retain a few fresh brushmarks of its own while allowing the ridges and furrows of the underpainting to show through. While this was wet I sprayed on a lighter bluish mixture by flicking the bristles of a brush loaded with very thin, oily paint. This seemed to show where the fur was pointing back towards the viewer.'

## shortcuts

### Texture making

Martin used thick paint applied in the early stages with a worn brush to create the texture of the bee's 'fur', but there are many other ways of creating texture in an oil painting. For example, Martin also used drybrushing on the bee. This works best if there is already some texture on the support such as the weave of the canvas. A small amount of neat paint is skimmed lightly over the dry surface to leave a broken trail of colour. This is particularly apt for rendering hair or the texture on driftwood, for example. For more extreme textures artists can apply paint thickly and sculpt it with a knife or mix it with sand and sawdust or texture mediums which give it more body. However, remember that some smooth areas are needed to contrast with the textured ones. These can be created by smoothing with a knife or by brushing out.

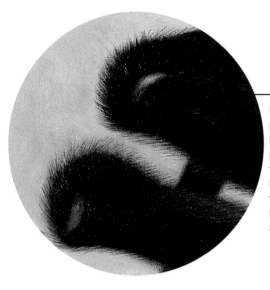

Using flicks of a fairly dry brush, Martin painstakingly recreates the hairs on the bee's body. Notice that these aren't all painted in simply one colour but range from a light raw sienna to Martin's blackish mix of alizarin crimson and viridian which not only adds interest but which makes the hairs look softer and more natural.

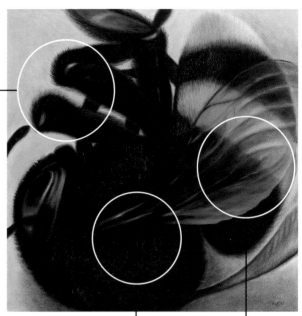

The textured underpainting helps recreate the 'furry' thorax of the bee and enlivens this potentially dead area. In real life the textured marks here and on the abdomen will catch the light, adding to the 'touchability' of the image.

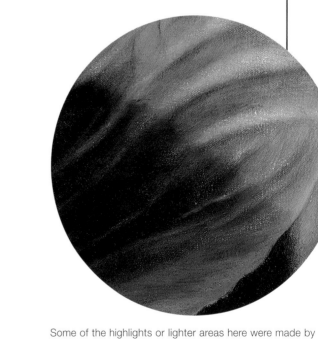

Some of the highlights or lighter areas here were made by 'dragging back', either with a stiffish brush or a cloth dipped in turps. By doing this over the almost but not completely dry underpainting, Martin was able to go right back to the stained ground beneath. Then a very fine, milky glaze was put over the top, recreating the gossamer quality of the wings.

# STILL LIFE OILS

Colour is very important in this artist's work, but for her anything can spark off an idea for a painting. 'This bowl often stands on the kitchen table. One day I took it to the studio. Thinking of the colour composition, I set it up with an Indian patterned scarf. The particular colour of the Spanish pottery, the oranges and the pink patterned cloth set up an exciting colour scheme to work with which enabled me to extend my visual awareness further. I attempted to erase any memory of having seen a similar subject before so I could look at it afresh.

'I painted this at a time when I felt a private need to "touch base" and look at the intricate colour relationships and qualities of reflected light cutting across form and texture. I wanted to paint in a straightforward way with all the immediacy of the objects standing in front of me.'

Although Pam regards still life as a comparatively approachable and direct subject, this doesn't mean that she finds it an easy option. 'Still life is, of course, a relative term because everything continues to move – the light changes, the fruit is ripening and my response to the subject is constantly altering and evolving as the painting develops a life of its own. However, I do feel that it presents an excellent initial discipline for entering into a process of exploration and discovery.'

**Bowl with Oranges by Pamela Scott Wilkie** oil on board **30 x 38cm**

'Still life presents an excellent initial discipline for entering into a process of exploration and discovery.'

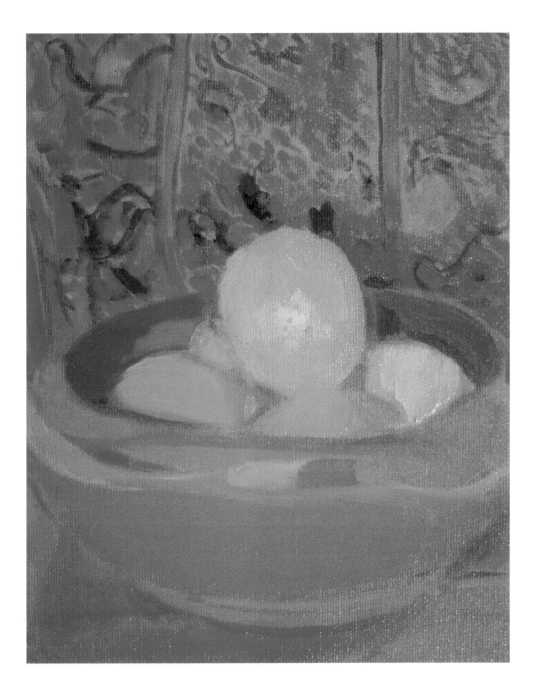

# Composition

'Still Life with Oranges' is one of a series of paintings based on still life groups. 'I started out each time from a specific arrangement and focused on abstracting something of its essence and quality of colour while retaining its original structure. Then I used this to explore the dynamics of colour harmony and resonance further. In this way one painting led to another.

'In "Still Life with Oranges" I was interested in the pictorial space and how the group of spherical oranges – the primary focus – is echoed by the scooped rim of the bowl, and how the triangular overall shape contrasts with this horizontal. This provides the underlying "armature" over which the play of colour and light takes place.'

Some of Pam's paintings are designed to hang in groups – 'I am interested in how the resonance of the colours can affect each other'. When working on a duo or trio she will plan them all together – they are not simply two or three paintings that happen to match. Here we can see the pastel sketch in which Pam planned 'TRIO 2'.

TRIO 2 (each 11"x12")
Permanent Rose
Indigo
Cadmium Yellow
Pam Satturini

## golden rule

### The Golden Section

The Golden Section was formulated by Vitruvius in the first century BC. He calculated a sequence which produces an harmonious balance which artists have adopted through the ages. This sequence is often found in Nature in the way a snail's shell increases or a tree forms its branches. It runs one, two, three, five, eight, 13, 21, 34 and so on and you'll need a compass and ruler to transfer it accurately onto your support (see Introduction). If you always use the same size of support you can calculate the divisions of the Golden Section just once and then simply transfer them to the next support, but most artists do it by eye – the Golden Section approximately divides the support in the proportions of a third to two thirds both horizontally and vertically.

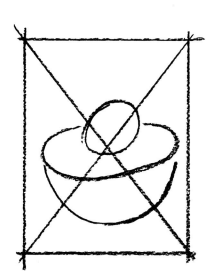

Pam has placed the large top orange in the very centre of the painting. This is a position of great importance because it is usually where the viewer looks first and it confirms the status of the oranges as the main focus of the work.

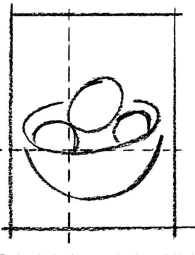

For hundreds of years artists have divided their supports in accordance with the Golden Section (Golden Mean) to produce pleasing proportions. Pam often uses this principle, as we can see here, but she also stresses that 'rules are made to be broken; creativity is about taking risks and constantly pushing at the boundaries'.

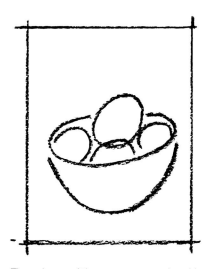

The spheres of the oranges are echoed by the curved lip and base of the bowl to produce a pleasing harmony. This contrasts with the near verticals in the patterned cloth, creating balance.

'No object can be tied down to any one sort of reality; a stone may be part of a wall, a piece of sculpture, a lethal weapon, a pebble on a beach or anything else you like.'
(Georges Braque 1882–1963)

# Colour

Colour is of vital importance to Pam because, 'the overall colour harmony as emotional expression and what I see are intertwined'. She is also inspired by the way in which the resonance of colour has parallels with music and therefore much admires the work of painters like Kandinsky, Klee and Rothko. Typically she works with a relatively small number of colours drawn from those she has in her studio.

## The artist's palette

In 'Bowl with Oranges' Pam predominantly used cadmium orange, permanent rose, phthalo turquoise, indigo and titanium white but, 'a typical palette usually consists of a selection from: titanium white, lemon yellow, cadmium yellow, cadmium orange, cadmium mid red, permanent rose, alizarin crimson, cobalt blue, phthalo turquoise, viridian, indigo and black with the earth colours, particularly raw sienna, Indian red and burnt sienna'. Pam also pulls in other colours to answer specific situations and give some surprise as in 'Lime Fruit on Cloth from Sri Lanka'.

**Lime Fruit on Cloth from Sri Lanka** oil and gold leaf on canvas **28 x 30cm**
For this painting Pam added new colours to her palette – cobalt green and mauve blue shade. She also introduced a little gold leaf in the bottom-left corner, using it as another colour to add life and sparkle.

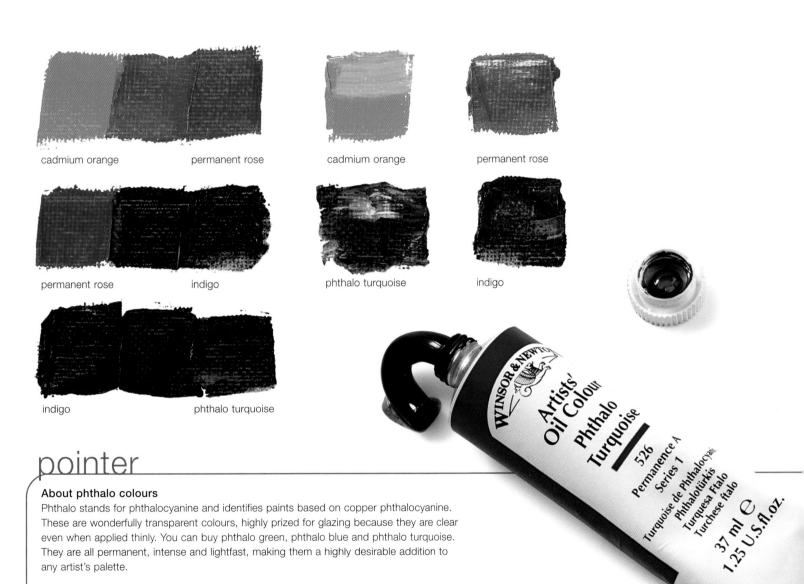

cadmium orange        permanent rose          cadmium orange          permanent rose

permanent rose        indigo                  phthalo turquoise        indigo

indigo                phthalo turquoise

# pointer

### About phthalo colours

Phthalo stands for phthalocyanine and identifies paints based on copper phthalocyanine. These are wonderfully transparent colours, highly prized for glazing because they are clear even when applied thinly. You can buy phthalo green, phthalo blue and phthalo turquoise. They are all permanent, intense and lightfast, making them a highly desirable addition to any artist's palette.

# Technique

Many artists will say that one of their hardest problems is knowing when to leave a painting alone. Of course, there is a small band of artists who are too impatient to linger long on any one painting because their minds are whizzing ahead to the next piece, but for the majority overkill is the danger. A good way round this is to leave the painting on view for as long as it takes and start working on other things, letting the painting linger in the back of your mind until problems resolve themselves and you feel able to return to it with a clear plan. This is how Pam works. 'My paintings take a long time to finish. I live with them for months myself and they don't leave the studio until they seem to have an anonymous life of their own and are able to give off their own light in all lights. This is usually when all the effort and hard work somehow disappear and nothing more can be added or taken away. The paradox is that this is when a personal voice and poetry can make their appearance.

'Over the years I suppose I have developed my own method of painting based on traditional methods. I usually start painting "thin" and finish "fat" in the traditional way because this is simply common-sense good practice. For texture I sometimes add powdered pumice and sand and every so often, if I have a canvas I want to destroy, I will use it as the basis for a new painting because scratching the surface to reveal a layer of colour below is another method I have come to use.'

'My paintings take a long time to finish. I live with them for months myself and they don't leave the studio until they seem to have an anonymous life of their own and are able to give off their own light in all lights.'

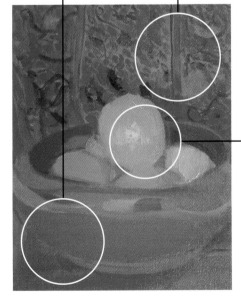

Pam has painted the area around the bowl in the same colour as the Indian scarf. This ensures that there is no disruption to the colour harmony and does not draw our attention as a contrasting colour would.

The Indian scarf in the background introduces pattern in an otherwise rather plain set-up and therefore provides a change of pace. It is rendered in sufficient detail to create interest but isn't so finely worked that it draws attention away from the focal oranges.

Dabs of pink paint on the orange suggest reflected colour from the bowl and background and contribute to the warm colour harmony.

MIXED MEDIA

# STILL LIFE MIXED MEDIA

Jenny's paintings are often worked in her own colours, made from pigment mixed with gum Arabic solution. By varying the dilutions of the gum Arabic solution Jenny is able to control the thickness of her paints, giving a much greater potential to vary the quality of the medium from the thin transparency of a dye through to a jelly-like solution which handles more stiffly and can be moved about a bit on the paper.

The inspiration behind Jenny's work lies not so much in wishing to create an image per se but in the desire to express a feeling or meaning as a form of personal release. This feeling or meaning was never the validation for a painting and so Jenny didn't really feel the need to disclose it. However, recently she has started to hint at the meanings behind the work. This painting, for example, is called 'Conversation Piece' but it is about communication in general, and the separation of the tables hints at the lack of communication between people.

**Table Conversation by Jenny Wheatley** mixed media on paper **81.5 x 84cm**

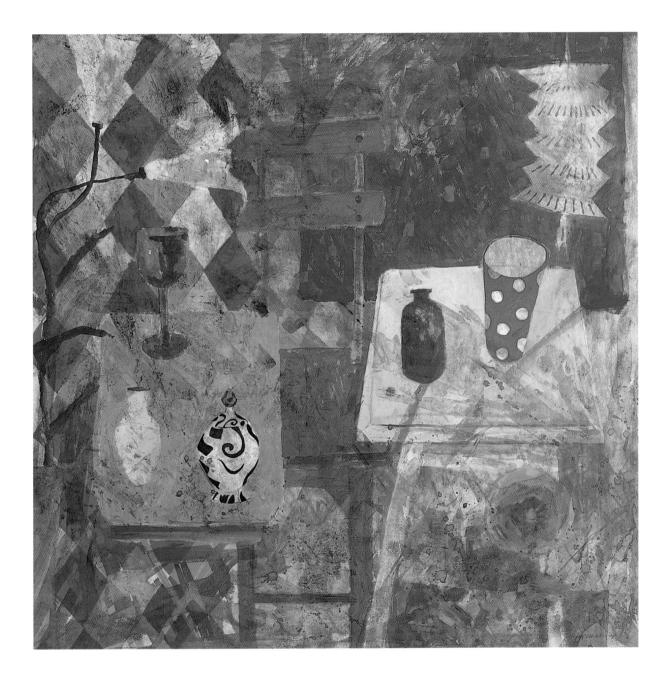

# Composition

Like many artists, Jenny tends to paint constantly, often working from a number of objects which she likes to set together. Although she may depict the same object in several paintings this doesn't make the arrangement of the still life set-up any easier, and she describes setting up her displays as 'a huge investment'. However, even once the set-up has been finalised, the composition of the image is not set in stone and Jenny may move things about on the support if it makes for a better composition.

Notice that the support is nearly square. Although Jenny also works on other formats, such as very wide supports, she enjoys the challenge of, 'trying to make sense out of a square or near square'. The usual format is a rectangle. This is pleasing and somehow feels 'right' because it conforms to our field of view when we look around us. Turning that rectangle on its short edge for a portrait picture also looks right, perhaps because it fits the human form so well, but a square can look contrived – too perfect. This makes it something of a challenge, although it can be favoured by artists who are more interested in the qualities of surface and colour than in representational work and who want to remind us that this is, after all, a picture.

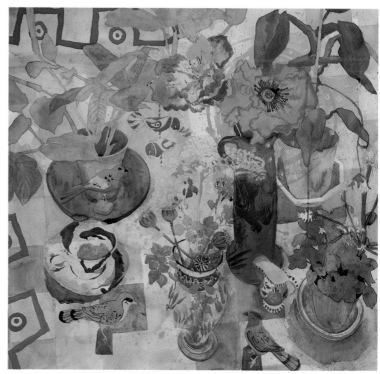

**Floral Display** mixed media on paper **95 x 105.5cm**
This painting was titled by the gallery which displayed it so we can only guess at the meaning or feelings which motivated it. However, it has a happier, sunnier mood than 'Conversation Piece' because the items are clustered closer together and there is no alienating space in the middle. Instead, when we look at the heart of the painting we find a spray of yellow flowers, opening up to the world and leading us to the burst of red in the poppy head.

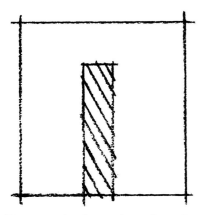  

The centre of an image always demands our attention, and here we are constantly drawn to the chair which cuts the support down the middle and holds the two tables apart like an unwanted event or a person who is getting in the way. Yet at the same time the chair seems to be supporting the tables, perhaps acting as a mediator, creating a fascinating ambiguity.

Behind each table is a different background, one in blue and quite sparsely decorated, the other in warm colours, embellished in a bold harlequin pattern. The left-hand edge of the chair which divides these two areas falls on the Golden Section (see the Introduction), as does the bottom edge of the right-hand table. This division is a traditional one, said to separate the support into the most pleasing proportions, and although Jenny would have followed this division more by eye than by design, it does result in a very balanced image.

Two sets of flowers – poppies and lilies – balance the composition in diagonally opposite corners, while the Chinese lantern and white vase, linked by their colour, lie on the opposite diagonal. These embellish what might potentially be large empty areas of the composition and they also add balance. Since the vase is not quite in the corner and all four items are very different they don't make the image appear at all static, as they might if they were more similar and symmetrically placed.

## golden rule

### Symmetry and balance

When composing with two large and very similar objects, like these two tables, it would be easy to start making things look symmetrical. This can produce a very formal, static and even dead image so it is best avoided unless it is appropriate for a point you are making. However, even without symmetry it is generally most satisfactory if an image feels balanced as it creates the greatest harmony. Jenny has staggered the tables to break the symmetry so in order to maintain a sense of balance she had to add other objects to create an equal 'weight' on each side. Thus began a process of balancing and rebalancing, adding an object to one side, then to the other as if they were on a set of scales until everything felt level and balanced.

# Colour

'I have a very wide palette. I suppose I tend to use some 20–25 colours and I seldom go outside that unless I see one that looks rather juicy at the suppliers. I work with colour in a layered way, and enjoy playing about with colour theory to make things come and go in a rather theatrical way. Often I might see how far I can go breaking the "rules" without actually destroying the image.'

For 'Conversation Piece' Jenny worked from paints she had made herself so that she could vary the consistency and sometimes work back into them, creating a texture that we can look right down into. Another advantage of working from her own paints is that she can utilise the different qualities of the pigments. Some pigments float and are chalky and resisting while others dissolve readily, producing an effect like a dye. By using a thicker or thinner solution of gum Arabic, Jenny can bring out or tone down these qualities, whereas with ready-made paints the manufacturers try to average out the differences between paints, producing a standard product which is easier to use but perhaps too predictable and a lot less fun.

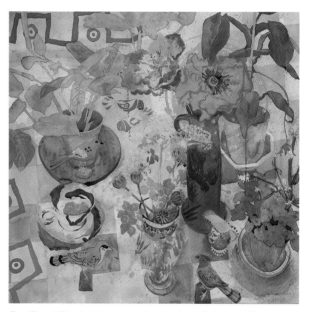

For 'Floral Display' Jenny worked in, 'a softer way with thinner paints to make the painting glow like stained glass. I pushed the image, seeing how many colours I could lay on without it developing into impasto.' Here the light of the paper shines up through the painting whereas in 'Conversation Piece' the colours are thicker and more textured so we are drawn down into it.

### The artist's palette

The pigments Jenny used to make the paints for this painting were titanium white, lemon yellow, cadmium yellow, raw sienna, cadmium orange, yellow ochre, red umber, red iron oxide, primary red, vermilion substitute, solferino lake, cobalt blue, ultramarine, cerulean, viridian, cobalt turquoise, cobalt violet light and magenta.

lemon yellow

cadmium yellow

raw sienna

yellow ochre

cadmium orange

red umber

red iron oxide

primary red

vermilion substitute

solferino lake

cobalt blue

ultramarine

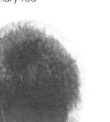

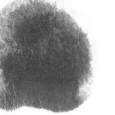
cerulean blue

viridian

cobalt turquoise

cobalt violet light

magenta

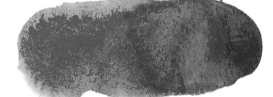
solferino lake

ultramarine

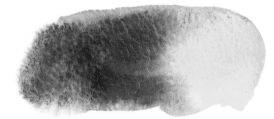
cobalt blue

cobalt violet light

viridian

lemon yellow

# Technique

Jenny tends to work in a fairly traditional way, 'from the general to the specific', working over the whole area of the support and bringing it all along at the same level. However, it does depend on what she is trying to put across, and if she wants to convey, say, a disjointedness, then she works that way too, chopping and changing about from place to place. In general Jenny works in layers, starting by bringing up strong but soft edges. 'Then slowly things are found by what I put in or leave out. If I find that things have become too hard then I'll add new washes, coming and going and playing with it and the rules until I achieve the effect I want.'

## shortcuts

**Making watercolour paints**
Watercolour consists of fine ground pigment mixed with gum Arabic solution with just a little glycerine to help prevent cracking and a wetting agent, such as ox gall, to ensure an even flow of the paint over the paper. Some pigment suppliers will give you a basic recipe for making your own watercolours, but the best results come from experimentation until you find the mix or mixes which suit you best. Jenny always has more than one solution of gum Arabic on the go so that she can select the one closest to her requirements, although as she points out, you can always water it down.

Here you can see how Jenny works in layers, applying the blue over a pinkish colour which approximates to the colour of the Chinese lantern. Allowing the undercolour to show through in places creates a lively surface and helps to harmonise the painting since we see the same colour cropping up in many places.

Close inspection of any area of the painting reveals the complex layering process, with edges lost and found, shapes added and then partially hidden, which brings the painting up to its finished state.

Notice the splatters of turquoise green which lead us on a trail up to the green vase on the right-hand table and to the black and white pot on the left-hand table. These marks not only serve to provide additional textural interest and colour but also act in a compositional role, leading us up to the focal points.

# STILL LIFE MIXED MEDIA

'I choose my subject matter quite intuitively – anything that attracts my attention in some way or other, by shape or colour or by some association which to me is significant. The smooth contours of the fish, with their subtle textures and colours appealed, and I found it interesting that although I was working from dead fish they still had a character which I consciously tried to capture. I think that you can too easily become detached from the image in creating a still life which can result in a rather clinical response. The difficulty is in keeping your approach fresh.

'Working from still life is certainly a convenient subject, easy enough to set up and leave over a period of time, but unfortunately with fish they can start to smell rather badly after a few hours! Also, if working in natural light you can only paint during a fairly limited period of each day, otherwise constantly changing tonal values present a problem.'

**Mackerel on a Blue Plate by Beverley Schofield** acrylic and pastel on paper **70 x 50cm**

## 'Although I was working from dead fish they still had a character which I consciously tried to capture.'

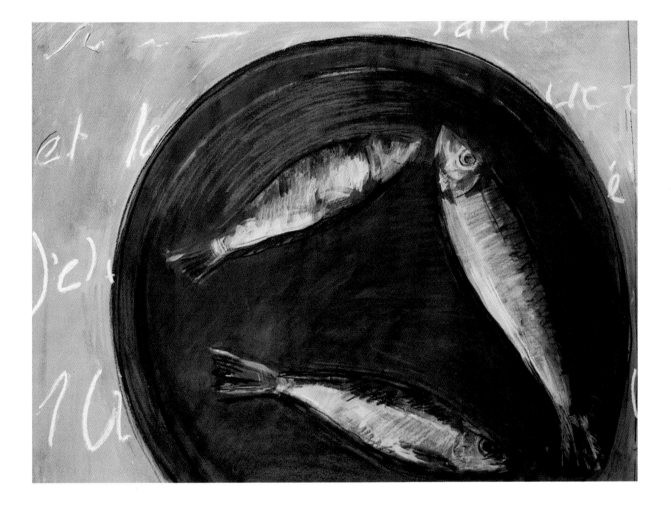

# Composition

'I tend to work on themes and follow the same pattern of working through ideas. First I produce a series of sketches and drawings in a variety of media which explore my ideas about a chosen image. To start with I might make rough sketches in pencil or charcoal and then use these to develop ideas in more substantial media. These studies may be fairly straightforward observations or they can be quite experimental, playing around with different combinations of media, composition or style. Eventually I will try to make a more finished statement in the form of an oil painting or series of oil paintings.

'My pictures are all based on some point of reference although I will quite often leave out, add to or change things about a subject before I have finished. I am less interested in the actual likeness of things than in setting up relationships between the objects and the space around them.'

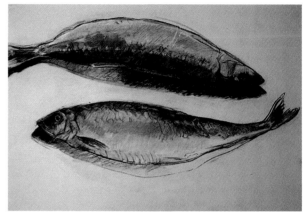

**Fish Study** pastel on paper **69 x 50cm**
Notice the dimensions of this study – Beverley tends to work large, even in her preliminary pieces. This is good practice because it means you don't have to fiddle about trying to fit the details in, and it makes for much easier reference since you won't have to peer at what you've done. Beverley usually follows the same pattern of working, starting by making sketches and drawings in a variety of media to explore a range of ideas.

## golden rule

**Negative space**

The area around and between the subject(s) in a painting is known as negative space and it has an important role to play. Each area of negative space – a negative shape – helps to determine the outline of the main object. It is therefore an ideal checking method for an artist to look at the negative shape made, say, between several fish on a plate, to see if the main objects are accurately mapped in. If the negative shape is wrong, then the drawing is inaccurate. In addition, as Beverley says, negative spaces can also provide quiet areas which allow attention to be focused on the main subject and which provide a chance for repose.

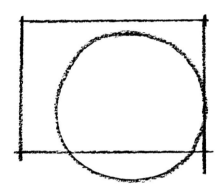 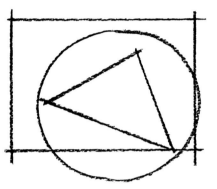 

Beverley often chooses to crop her subjects at the edges to give the impression that they exist beyond the confines of the support. This technique was adopted by the Impressionists, notably Edgar Degas (1834–1917), and was very much a result of the influence of photography.

Notice the simple geometric shapes in this composition which, being familiar, are highly pleasing. In the centre is the triangle formed by the three fish, then the circle of the plate (partially cropped but filled in by our minds) and finally the rectangle of the support.

Empty space is important to Beverley in a picture: 'I feel that you need quiet areas to heighten the impact of the main image'. By moving the plate to the right of the support Beverley produces a bigger block of 'negative space' while still allowing the plate to fill the support to bursting (see Golden Rule).

# Colour

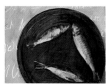

'I tend to naturally limit the range of strong colours that I use in any particular painting. Quite often my pictures will be largely greys with subtle tints and just one or two splashes of bright colour, usually ultramarine or cadmium red. Although I may have mixed several paints together to achieve the final colour of a subject I try not to clog up the image with too much detail and flecks of colour. I prefer smoother, cleaner colour.

'In using colour I will generally start off by painting what I see – I tend to select objects that work for me in terms of colour. However, quite often as a painting develops the colours become far more subjective and can end up bearing little resemblance to my starting point.'

## The artist's palette

'When working in oils I always use ivory black and titanium white, preferring their compositions to those of the other blacks and whites available. I like the strength of the cadmium pigments and have a few other favourites such as Naples yellow, cobalt blue and French ultramarine. I have difficulty with greens and tend to mix them from blues and yellows. Also I find you have to watch Prussian blue as a painting can quite easily drown in it. With oil paints I tend to use Winsor & Newton's artists' colours; for acrylic work I like Rowney's Cryla Flow and for pastel work I use a mixture of soft and hard makes.'

Naples yellow

cadmium lemon

cadmium yellow

cadmium red

cobalt blue

French ultramarine

ivory black

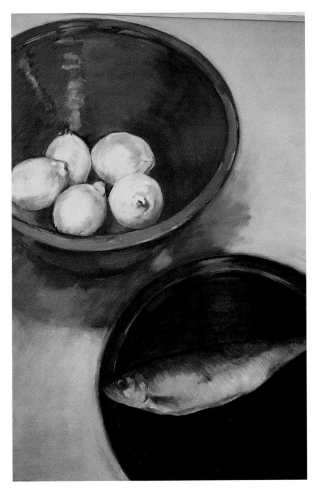

cadmium yellow          cadmium red

Naples yellow          cobalt blue

French ultramarine          cadmium lemon

**Lemons and Fish** oil on canvas **94 x 79cm**
'In this painting I used three areas of localised colour. I spent some time trying to achieve a green that would sit well with the bright yellow of the lemons. The final green was quite different from the actual colour on the bowl but it worked much better.'

## pointer

### About Prussian blue

This vibrant green-blue is so powerful that it must be handled with care or it will quickly overrun a painting. Its strength means it can even stain the support and sometimes leach into overlaid paints. However, this holds true for several popular colours, including viridian, and should not necessarily dissuade the artist. A more tricky problem is that Prussian blue can take on a bronzy sheen and tends to be very oily which can lead to wrinkling. Nevertheless its vibrancy and transparency make it an attractive addition to the artist's palette.

'Nature and art, being two different things, cannot be the same thing. Through art we express our conception of what nature is not.'

(Pablo Picasso 1881–1973)

# Technique

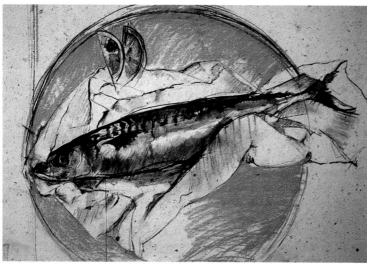

'I like to use a variety of materials and approaches and constantly review and develop my techniques. For drawing I like the immediacy of charcoal – you can smudge areas to create atmosphere or use it like a pencil to define edges with some clarity. Charcoal works particularly well on handmade papers which I have a preference for. I find that mixing materials can also create interesting effects. I will often use acrylic paint and draw into it with pastels or combine collage, paint and oil bars – whichever selection achieves the desired effect as I build up a picture.'

**Mackerel Wrapped in Newspaper** pastel and collage on paper **44 x 36cm**
Like Picasso, Beverley sometimes uses newspaper to represent itself – here the wrapping provided with the fish.

**Mackerel on Paper** charcoal, pastel and ink on paper **76 x 58cm**
Beverley uses whatever mediums seem most appropriate for creating the image. Here, a charcoal drawing is reinforced with black ink while pastel provides tonal variations. Notice the fairly neutral colours which Beverley favours – she does not bring out the potential colours reflected in the scales on the mackerel's back but plays these down to emphasise form.

Long sweeps of French ultramarine pastel add a wonderful colour accent and help to describe the contours of the plate.

The important background area is painted in a neutral colour which does not detract from the main subject matter. Notice the apparent words written in white which we can't quite read and which therefore add a certain mystery.

Beverley creates a rich violet colour where the brown reflected from the mackerel tinges the blue of the plate. Notice how these colours merge into each other, from blue to violet to reddish brown.

# STILL LIFE MIXED MEDIA

You could be forgiven for assuming that this is based on a genuine view through a window, but in fact it has been compiled by the artist's imagination out of a landscape and some still life objects. Barbara perceived at once that the scene would work if presented as a view through a window. 'On this particular day there was a wonderful blue distance with the simple shapes of the cottages set against the dark trees while the middle distance had subtle rhythms which I exaggerated in my final painting. In my mind's eye I thought of the scene becoming a window painting with a still life in the foreground.'

The idea of still life with landscape beyond is a haunting theme for the artist and she points to Mary Fedden's work in this area as a source of inspiration. She is also influenced by Ben Nicholson's window paintings of St Ives, Cornwall and the way the two elements of still life and landscape in his paintings confront and yet at the same time welcome each other.

**Still Life in Charnwood by Barbara Stewart** mixed media on board **81 x 81cm**

'A painting must speak with more than one voice to many people.'

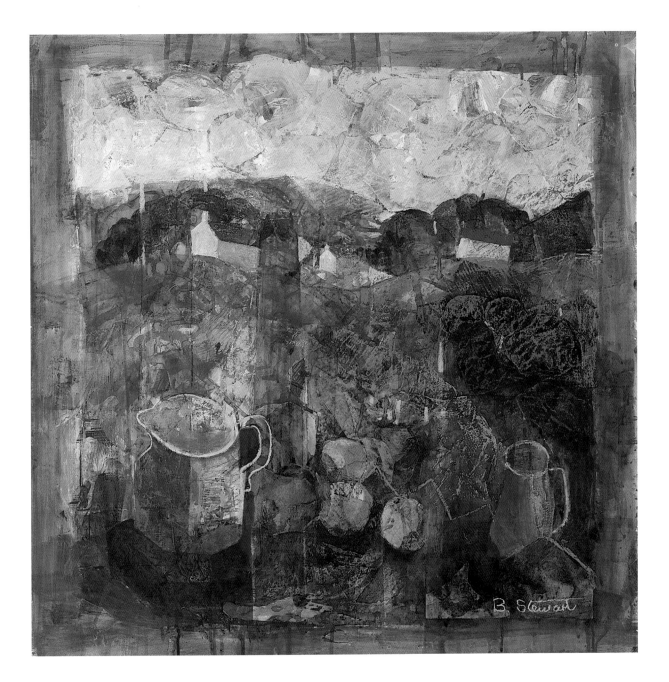

# Composition

With the landscape in front of her, Barbara made a pencil sketch with colour notes, 'looking for simplified shapes'. Back in her studio, 'I set up a favourite blue jug and mug and added some oranges. I set a spotlight on these items to give me some dramatic contrasts, then made a further charcoal sketch on sugar paper incorporating the landscape and still life. I used vertical stripes to link the two elements.'

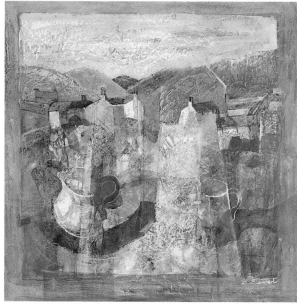

**Below the Mountain** mixed media on board **81 x 81cm**
Barbara has structured this painting in distinct bands, with the sky at the back, followed by the hills, then the row of houses on their bank and finally the still life elements at the front. There is no attempt at aerial perspective because this is a painting about shapes and textures, rather than a photographic reproduction of real life. Near vertical lines break up the image into further sections like the view through a kaleidoscope, reminding us how light can fragment colours and shapes.

This is Barbara's initial sketch for 'Still Life in Charnwood'. Notice the way she has broken up the image into tonal divisions so she can check the balance of the painting as a whole. In the final image most of these basic elements remain in place but Barbara has altered shapes and added fresh elements as seemed appropriate while she was working.

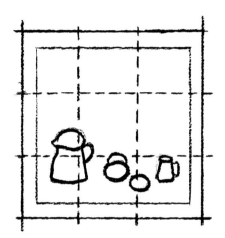

You might expect a painting of a view through a window to be composed in two distinct parts, one being the window itself plus the items inside the room, and the other being the view. Barbara integrates the two by setting the still life objects in the landscape, just outside the window, and by using the same colours for both elements. Because of this the two parts sometimes seem to merge and sometimes to move apart, jostling for position like a married couple.

Notice how the orange-brown area of land in the near distance could double as the table on which the still life objects are standing. This duality encourages us to look closer at this area, seeking out the forms of other objects – are they part of the still life arrangement or objects from the landscape?

Tradition has it that it works very well if focal points are placed roughly a third or two thirds of the way in from the edges of the support. Here the row of houses is roughly a third of the way down and extends up into the top third while the still life objects fall into the bottom third. The three still life elements (jug, oranges and second jug) divide the support into thirds vertically, separated as they are by streaks of blue.

## golden rule

**Calming horizontals, energetic waves**

'Still Life in Charnwood' seems to be made up of a number of undulating horizontal bands – the sky at the back with the hills in front of it, then the trees, then the houses, the sweeps of the landscape and finally the still life objects in the foreground. Horizontals in an image create a very calm, even static mood which encourages contemplation but here the lines are far from straight, even turning into energetic diagonals in the bottom-right corner which give the image a lot of power and movement. Indeed, the curvy lines are so energetic that Barbara has felt the need to stabilise the image with the vertical blue bands which act like pillars in a house to support the structure.

# Colour

The tactile quality of paints, sometimes liquid, sometimes thick and oozing, and their luscious colours are a great pleasure to all artists. Because Barbara doesn't stick to any one medium she can take advantage of the wonderfully varied qualities of all the different paints, perhaps creating semi-transparent glazes, perhaps rubbing on solid colour in the form of pastel or introducing line with charcoal. For this painting Barbara used mainly acrylics and acrylic ink with charcoal and pastel, applying a collage of thin, torn paper painted in acrylic where she felt it was needed.

## The artist's palette

Barbara used white acrylic gesso as a base for her painting and then applied a number of Daler-Rowney acrylic paints on top: raw sienna, cadmium orange, permanent rose, French ultramarine, monestial blue, cobalt blue and sap green. She also used FW acrylic inks, also by Daler-Rowney, this time in turquoise and marine blue and she added black gesso as a mixing colour. Over this she applied charcoal and a range of Unison pastels: pale blue (BV8), blue (BV9), violet (BV3), orange, and sienna grey (19, 20 and 21).

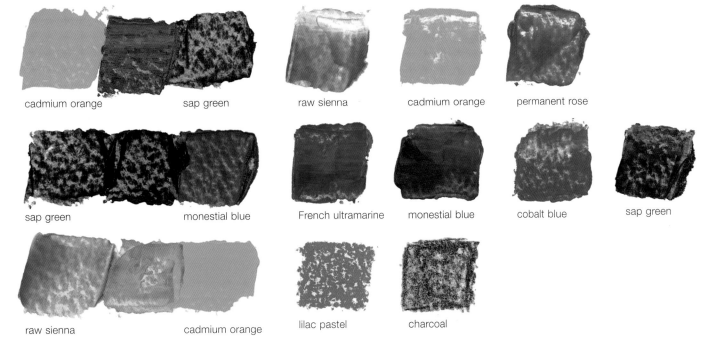

cadmium orange     sap green     raw sienna     cadmium orange     permanent rose

sap green     monestial blue     French ultramarine     monestial blue     cobalt blue     sap green

raw sienna     cadmium orange     lilac pastel     charcoal

# pointer

## Choosing your blues

There are some wonderful blues available to the artist today and few can resist having at least two in their collection, if not several more. The only true violet blue (warm) is ultramarine which was originally produced from lapis lazuli but is now made synthetically. It is warm, lightfast, transparent and usually clear. Of the green blues (cool) there are several to choose from. One of the lightest is cerulean, a bright, opaque sky blue, which is absolutely lightfast but has a low tinting strength. For a slightly darker shade, choose phthalocyanine blue, an intense, transparent blue with good lightfastness (also sold as monestial blue and Winsor blue). The deepest green-blue is Prussian blue which is extremely strong and transparent. Its transparency and depth make it highly attractive but its great strength makes it difficult to handle. Of the mid blues, cobalt is probably the best. It can lean slightly towards violet or green depending on the manufacturer. It is lightfast but has quite weak tinting power.

turquoise

marine blue

# Technique

'I work on mount board which is randomly prepared by gluing pieces of newspaper all over the surface with P.V.A. (wood) glue. The glue seals as it sticks and makes the newsprint permanent. A further coat of the glue gives a very robust surface. When this is dry I coat the board with white acrylic gesso applied with sweeping brushstrokes which dry to produce further texture.

'For this picture, and for "Celtic Mood", I mixed monestial blue, a touch of black gesso and marine blue acrylic ink in a small pot with some water. With the board flat on the floor, I drizzled the paint over the picture area and moved the board around in different directions to allow the paint to flow. Then I tonked it all over with newspaper [see Shortcuts]. When this was dry I gave the board another acrylic glaze in an appropriate colour. It is only at this stage that I decide which way up to work on the square board.'

After this Barbara used charcoal to draw in the composition and then applied her paints. Where appropriate she added pieces of torn paper which she had previously painted. These were sometimes worked over again in acrylic or pastel.

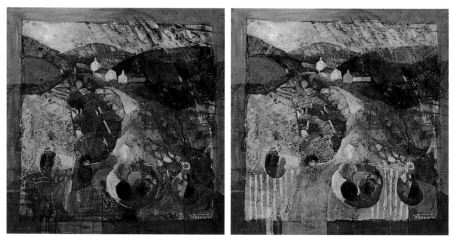

**Celtic Mood** mixed media on board **81 x 81cm**
Barbara can continue to tinker with her paintings long after a less critical viewer would say it was finished. Above left is 'Celtic Mood' after the first phase. After some consideration Barbara decided that the overall effect was too dark. She made the greatest transformation to the front, lightening the area around the still life objects and adding the dynamic stripes. To balance this she also lightened the middle ground and the hill on the right.

## shortcuts

**Tonking**

Sir Henry Tonks, Professor of Painting at the Slade School, England, invented this technique which makes it possible to paint over areas which aren't yet dry. Simply press a piece of absorbent paper on top of the wet area and peel it off to remove excess oil and colour, but be careful if you choose newspaper because the print may come off!

Barbara worked the sky on a separate piece of thin paper dragged over with cobalt blue. She tore this up into pieces and pasted the pieces on with P.V.A glue to suggest a bubbling sky. For harmony she washed over the top of the whole sky with a mix of cobalt blue and white.

This area started out as a clump of trees but Barbara wasn't happy with it so she pasted on some of her left-over sky paper and glazed it with a mix of cadmium orange and green. 'The area immediately above was finally resolved as rocks with the addition of some lilac pastel.'

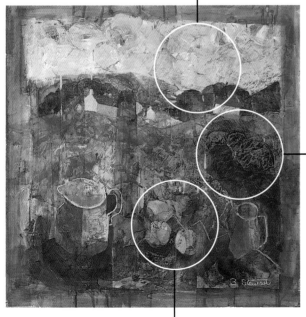

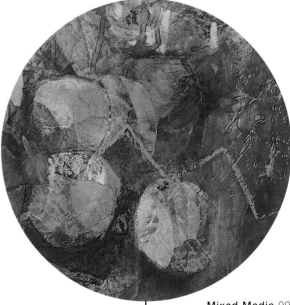

These oranges were not part of Barbara's original concept but were suggested by the background. They have been highlighted in pastel and linked to the jug on the right by a zigzag of orange pastel.

acrylic

# STILL LIFE ACRYLIC

At first glance this collection of items on a table appears to be so natural that we might just have come across it in a friend's home. We focus at once on the teapot and think that this is basically a tea-time arrangement. But what's this? Why are there three bottles of ink here, why is the teapot lidless and empty and where is the teacup or mug and the plate and knife for the fruit? Now we are intrigued and drawn in. Who lives here and what is this incongruous collection trying to tell us? The answer is that the artist lives here and that this arrangement basically just happened in the studio, although he added to it slightly. 'The ink bottles, the apple, teapot and striped bowl were just as they appear.' Such a happy accident had to be celebrated in paint.

**The Red Teapot by Terence Clarke** acrylic on canvas **46 x 46cm**

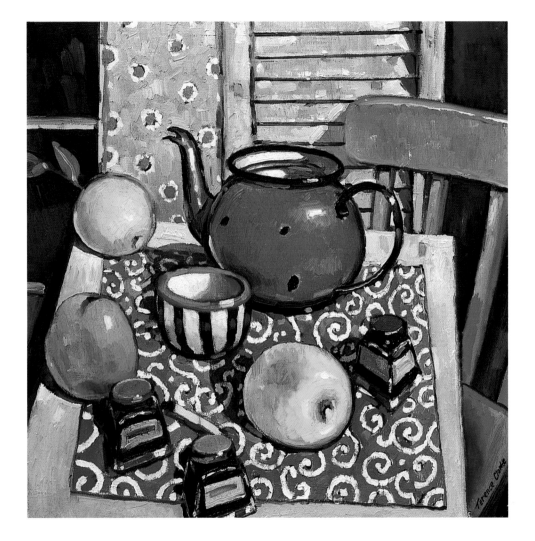

# Composition

'My compositions vary between something that is carefully "staged" and more casual, "accidental" or "found" groupings. "The Red Teapot" has both elements because I just happened upon it in the studio but adjusted the structure as the painting developed and added some elements in order to enhance the colour contrasts. It is particularly interesting to note the important contribution that the background plays compositionally and as a colour balance. The background structure deepens and enhances the quality of space and thus gives the objects more form. In addition, the natural greys in the background allow the more vivid colours in the still life to "breathe". The contrast between the louvered window shutter and dark blue window also helps key in the strong light effect created by the electric lamp which I used in this instance.'

## Arranged to look unarranged

'Compositional balance is everything in still life. Although there is a great deal of artifice in setting up the objects it is important to me that the objects look right but not too placed. Of course, the great master of this is Cézanne. In the end, the abstract qualities of paint texture, colour and structure are the real subject of these paintings.'

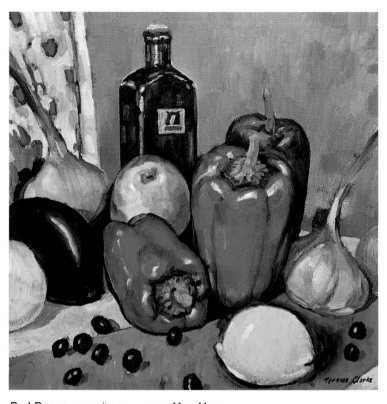

**Red Peppers** acrylic on canvas **41 x 41cm**
Compare the grouping of the items in this picture with that in 'The Red Teapot'. Here they are tightly packed, creating an intense, energised feel as if at any moment each fruit could throw off its neighbours. There is little room to breathe as the strong reds, greens, yellows and blues intensify each other in a crescendo of colour. In 'The Red Teapot', in contrast, items are placed quite widely, giving space for the eye to move around and between the objects at a leisurely pace for a more relaxed feel.

  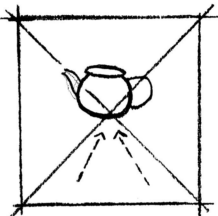

By viewing the items from an overhead position Terence emphasises the abstract qualities of the image: rather than simply concentrating on the individual nature of each piece we are made aware of the position of each in the overall scheme. Compare this with 'Red Peppers' where the eye-level viewpoint and close clustering of fruits makes us concentrate on each form rather than on the pattern-making qualities of the image as a whole.

If the image was made up solely of the table and the things on it we would find it quite abstracted, with the back of the table tilting up towards us and the ink bottles, in particular, about to slide forward. However, the background grounds the image and, as Terence says, it deepens the sense of space. It invites us to travel back towards it and thereby gives the items on the table more form as we feel as if we are moving among them.

Placing the teapot in the middle of the image but slightly high also invites us in. It is a vivid feature, being larger than the other items and attracts the eye by the intensity of the hue. The fact that it is above centre lengthens the 'journey time' towards it and we feel the sense of movement as we are pulled in.

## golden rule

**Leading the viewers in**

Most people look at a painting first from top to bottom and then back from bottom to top, particularly if the format is square or vertical. After this we look back and forth across the image or go where the artist leads us. Our eyes tend to follow continuous lines or contours, and the straighter and stronger those lines the faster we follow them. A bold stripe of colour leads us straight to the end while curving lines lead us at a slower pace. In 'The Red Teapot' we follow the avenues between the objects on the table as if exploring a garden. Its open layout encourages us to visit each feature at our leisure but we are drawn back repeatedly to the red teapot because of its size and stimulating colour.

# Colour

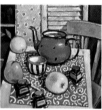

'The use of intense hues is a central element in these paintings and it requires a real balancing process to make sure that one element does not dominate. Colour sensation is created by contrast – red is only a strong colour if it is contrasted with other hues – so in "The Red Teapot" the green elements are distanced and help to create a balance with the red of the teapot. Even within a colour one has to continue to use contrast in order to maintain the colour effect. For example, the teapot is composed of vermilion, process red (magenta), orange and yellow. All these hues create a series of modulations within the red which enliven the colour. Similarly the yellow apple is a mixture of cadmium yellow, lemon yellow, orange, pink and a touch of green.'

**The artist's palette**

'I use a combination of acrylic paints, mainly Daler-Rowney System 3 and heavy body Cryla. My palette consists of black, process red, process blue, ultramarine and monestial green from System 3 and vermilion, lemon yellow, cadmium orange, yellow ochre and white from the range of Cryla heavy body acrylics.

'Painting is classifying one's colour sensations.'
(Paul Cézanne 1839–1906)

lemon yellow

yellow ochre

cadmium orange

vermilion

process red

process blue

ultramarine

monestial green

black

lemon yellow                    monestial green

ultramarine                     monestial green

vermilion                       cadmium orange

# pointer

**About green**

The human eye can differentiate more green hues than any other colour. This is probably related to our evolutionary need to read our natural environment in forests and grassland. Yet in the past this important colour was difficult to make to a satisfactory standard and many of the greens from previous centuries have now turned to browns, dull olives or faint blues. Luckily there are some wonderful, reliable greens available to the modern artist and if you choose carefully you need never worry about them fading. For a yellowish, opaque green try chromium oxide green which is highly reliable and can be easily mixed with a little blue for an opaque blue-green. If transparency is of key importance then select viridian or the slightly darker phthalocyanine green (also sold as monestial and Winsor green). These are both blue-greens and extremely strong so you will only need a little in your mixes.

# Technique

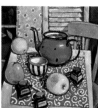

Terence works on canvases which he has prepared and stretched himself. He often puts a half-tone wash over the primed surface. 'This allows me to orchestrate the tones and colours more easily than by working straight onto a white ground.

'I draw out the basic structure of the composition with a thinned mixture of monestial green and ultramarine. Then I proceed to block in the main tones and colours, making sure that all parts of the painting are developed as a whole. At some point I adjust the drawing with the dark blue, then work up the detail. I always work wet-into-wet and so this means the paint has to be worked fairly rapidly because of the quick drying times that are characteristic of acrylic. I enjoy this aspect of acrylic as it helps me keep a spontaneous feel to the image. After a painting session I find it important to disengage from the image in order to see it objectively and then decide if it needs any small changes.'

## shortcuts

### Slowing down the drying time

The fast drying time of acrylic is part of its attraction but there are occasions when you want to slow things down. You can buy special retarder which extends the drying time to as long as a whole day, depending on how much you add but you shouldn't mix in more than about one part retarder to three parts paint or you will start to affect the consistency of the paint. Alternatively, dampen areas of the painting with a wet brush or do what Terence does and keep a plant sprayer of water handy to prevent the paint drying out. If you think you will want to continue using paints from your palette the next day then choose a special acrylic palette such as Winsor & Newton's Deluxe Acrylics Palette which helps retain moisture.

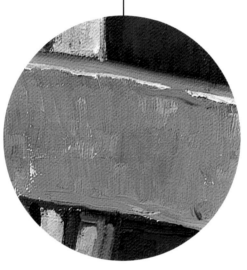

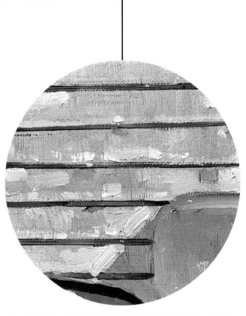

Notice that Terence hasn't filled in the blue of the cloth completely but allows some of the underlying colour from the table to show through. This 'broken colour' work helps keep the effect lively and prevents it becoming too dense and flat.

Terence combines several colours on each item, smoothing them on in thick, creamy applications without trying to blend the transitions so that from a distance the colours shimmer together to form one luminous colour while from close-to we see all the excitement of the brushstrokes with which each hue is applied.

An object's colour doesn't simply comprise of its local colour but of reflected colours from nearby objects. Terence emphasises these on the louvered shutters which have picked up some of the colours from the chair. This not only enlivens the picture but helps to create harmony and continuity.

# STILL LIFE ACRYLIC

This is a rather startling painting for several reasons. We do not see the cosy, comforting set-up we are so familiar with in still life paintings, and instead of following normal procedure and closing in on his subject, Joseph has drawn back to include a large background area which isolates the still life group and leaves us feeling slightly uncomfortable yet tranquil at the same time. Although the objects depicted are familiar, it is unusual to see them grouped together in a painting. In real life, of course, we might pop the flowers down on a chair with a jacket hanging on the back, but most paintings show rather idealised set-ups. Additionally, the precise rendering of the image stops us in our tracks. We can almost smell the leather of the jacket and the polish on the chair. Joseph often paints everyday objects in this way. 'The objects which I use in my paintings are taken from my immediate surroundings and are usually the humble objects found and used in normal life. In the paintings such mundane objects become imbued with nuances of thought and meaning which are at once universal and mysterious.'

**Leather Jacket & Tulips by Joseph O'Reilly** acrylic on board **65 x 80cm**

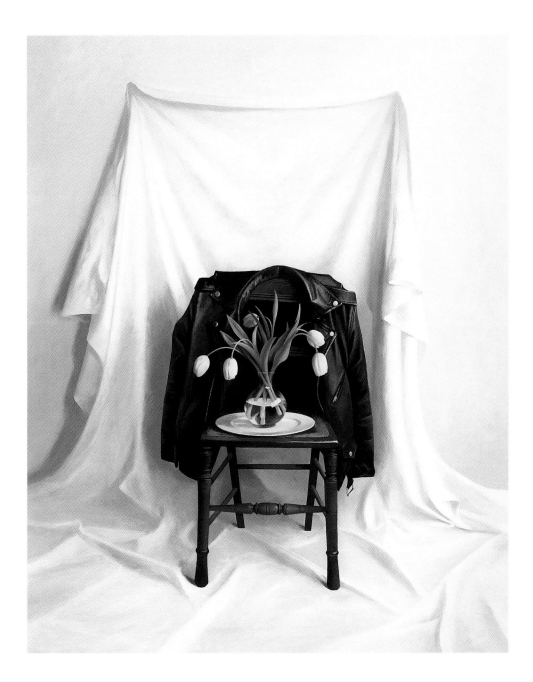

# Composition

'When I am arranging the objects in the studio I am very conscious of the way the light falls across them with the interplay of light and shadow.' Perhaps because he is so interested in light, Joseph's set-ups tend to be minimal, even stark. The play of light on the three-dimensional objects in the paintings is not confused by a riot of colour and form because objects are simple and uncluttered. It is almost as if Joseph revels in the shape, texture and touch of every object he sees, whether man-made or natural, and for him there is no need for further embellishment.

The chair sits firmly in the centre of the support with the angled lines of the tulip stems more or less marking the diagonals of the board. This, combined with the precise symmetry of the image, creates a highly static feel which encourages contemplation. It is a bold move because it only works if the brushmanship can stand up to this kind of close scrutiny – it can.

The actual subjects of the painting – the tulips and jacket – take up less than a quarter of the total picture area. The rest comprises the chair legs, the drape and the blank white wall. Again, this is a bold, radical approach because Joseph had to carry off the rendering of the drape and wall, but if you crop off this area with your fingers you'll find you are left with a very different picture which just wouldn't say the same thing.

## golden rule

**Energy levels**

All paintings have an energy level although most viewers are not directly aware of it. This can have a lot to do with whether we like a painting or not. An aggressively powerful painting with lots of bright colours and jagged lines can disquiet us and make us feel upset, while a very calm painting can leave us feeling either incredibly calm or rather sad. Most artists aim for something in-between. You can influence your painting whichever way you want. In general, bold colours are energising while neutrals and soft hues are more relaxing. Hard diagonals are powerful, waves can be merry and uplifting while symmetry and straight verticals or horizontals tend to be calming and quiet.

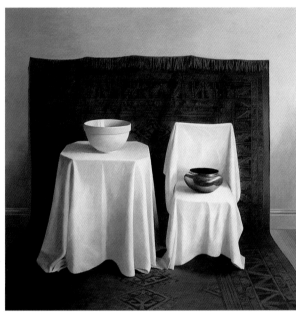

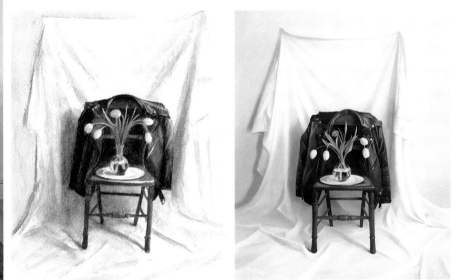

**Two Bowls** acrylic on board **70 x 70cm**

This painting has an even starker feeling than 'Leather Jacket & Tulips', partly because the two focal objects stand cleanly separated and all distractions have been removed or covered up so that we can concentrate on the bowls which stand unadorned like displays in a museum. Notice how the colours of the rug are played down until the metal bowl seems to shout for attention and immediately draws the eye. From there we jump to the white bowl, linked by subject to the metal one. We can almost touch this bowl, with its smooth inner surface – there is no conflict with the texture of the white drape, despite its proximity and shared colours.

Joseph starts his paintings by making 'small-scale watercolour paintings of the compositions which are my first impressions of the subjects'. As you can see, apart from adding a little more space above the drape to give a taller, thinner feel to the image, Joseph changed very little in terms of the composition.

Joseph often uses draped fabric in his paintings, sometimes as the background, as in 'Leather Jacket & Tulips' but sometimes further into the painting as in 'Two Bowls'.
He has found that it takes on a rather sculptural quality which adds an extra dimension to the work. This drapery is highly reminiscent of the fabric used to clothe figures in Renaissance paintings and beyond. Indeed, if this was painted a few centuries earlier we would fully expect to find a nude stretched out in front of the white drape in place of the chair. Such resonances add to the enigmatic feel of the work, as if it has somehow stepped out of time.

# Colour

'Many of my paintings use a limited palette of colours which are based on the observed colours of the real objects I have chosen. However, I take these colours from a relatively large selection of tubes or pots which I like to have at my disposal.' Joseph takes a wise approach in keeping colours limited, even if he likes to store up a few luscious extras for potential use because a limited palette helps to ensure a good colour balance in the painting. Allowing the brush to carry forward a little paint from mix to mix also helps to encourage harmony.

## The artist's palette

Joseph selects his paints from a large range. His neutrals include titanium white, neutral grey, unbleached titanium, raw sienna, burnt sienna, raw umber and red oxide. His yellows comprise brilliant yellow, cadmium yellow medium, Naples yellow, yellow oxide and lemon yellow. For blues he chooses from cobalt blue, ultramarine, cerulean blue, phthalo blue and Winsor blue. He uses three violets: prism violet, dioxazine purple and brilliant purple. For reds he selects from cadmium red light, cadmium red medium, napthol crimson, alizarin crimson, magenta and acra violet. His greens comprise chromium oxide green, sap green, emerald, Hooker's green and olive green. He also uses Mars black. These colours come from ranges by Winsor & Newton, Liquitex and Daler-Rowney.

## pointer

### About purple

Purple has been associated with royalty since Roman times when a pigment obtained from the body of a whelk was used to make an extremely expensive purple hue. Since then great efforts have been made to find cheap but reliable alternatives, with mixed success. You can, of course, mix your own using ultramarine and quinacridone violet or alizarin crimson, but if you'd like a ready-mixed colour try ultramarine violet which is produced by heating ultramarine blue and is a good purple colour or the slightly pinker manganese violet which is often sold under other names such as permanent mauve. Both are lightfast. Many manufacturers produce their own purples such as the ones that Joseph uses. Check with the manufacturer for their reliability before you buy as some violets may not be totally lightfast.

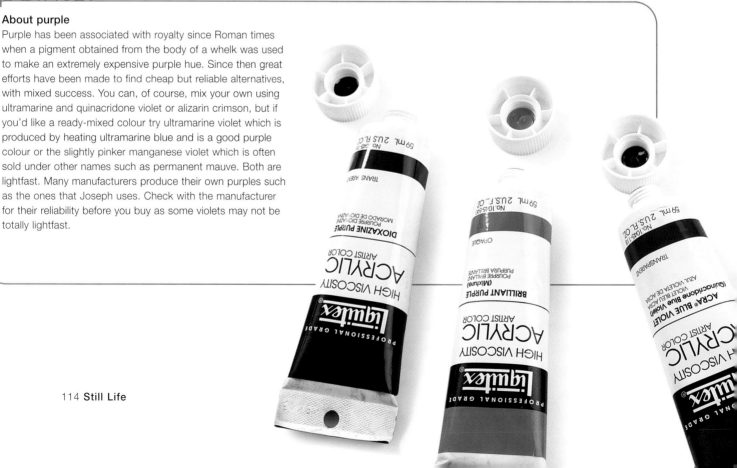

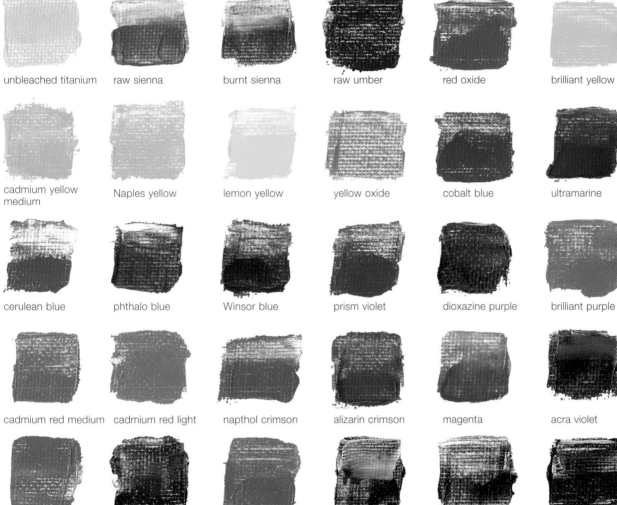

unbleached titanium     raw sienna     burnt sienna     raw umber     red oxide     brilliant yellow

cadmium yellow
medium     Naples yellow     lemon yellow     yellow oxide     cobalt blue     ultramarine

cerulean blue     phthalo blue     Winsor blue     prism violet     dioxazine purple     brilliant purple

cadmium red medium     cadmium red light     napthol crimson     alizarin crimson     magenta     acra violet

chromium oxide
green     sap green     emerald     Hooker's green     olive green     Mars black

# Technique

Using his watercolour sketch and the actual set-up for reference Joseph starts his paintings on thick hardboard which he has primed with acrylic gesso to give it a dense, solid white surface. 'When I start the painting I tend to use the acrylic paint very dilute – almost like watercolour – slowly building up the surface with washes applied one on top of another to develop gradations of tone. I allow the white primed surface of the board to show through and give the painting luminosity.'

To help him create such realistic effects Joseph works with quite fine brushes, using top-quality sable brushes (Winsor & Newton series 7) and slightly tougher, more robust brushes where he wants more texture (Pro Arte series 202). Brushes start at size 00 and move up to No.5, which is still not a huge brush for the size of support Joseph is using.

'Painting is the daughter not of Science but of Nature and Design. Nature points out her forms to her and Design teaches her to work.'

(Federico Zuccari 1542–1609)

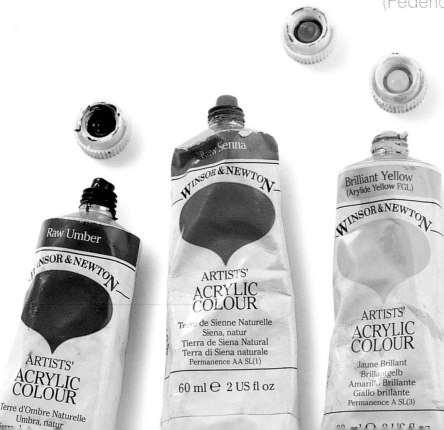

Joseph's rendering of the cloth makes it look sculptural, adding an extra dimension to the painting. The blues and violets in the shadows are reflected by the yellow of the light – all colours reflect their complementaries.

Black objects are as difficult to render as white ones since we feel afraid to add any colour other than black or white to them. Although showing very little reflected colour, Joseph has managed to capture the sheen of the leather and even the quality of the material through his subtle use of glazes and a little drybrushing.

We could almost reach in and stroke the fine wood of the chair seat it looks so real. Look closely and you can see how Joseph has built up the richness of the colour by applying many layers of thinned paint.

DRAWING MEDIA

# STILL LIFE DRAWING MEDIA

For Marguerite, the artist of these two spectacular images, still life is a subject with huge potential which is not often fully appreciated. 'Still life remains a subject prone to rigid assumptions but it does not have to be lifeless. So much of life can be expressed symbolically through the colour and placing of objects. I draw from what is observed in relation to that which is within myself and beyond.'

Although these images show a talented and experienced hand, pastel is not Marguerite's main medium. 'I use oil paint primarily. Pastel is a medium I began to use when time and space were at very low levels but since then I have found it to hold a very valuable place in my whole working practice.'

**Evening by Marguerite Elliott** pastel on paper **75 x 62cm**
**Sunrise by Marguerite Elliott** pastel on paper **89 x 101cm**

## 'I draw from what is observed in relation to that which is within myself and beyond.'

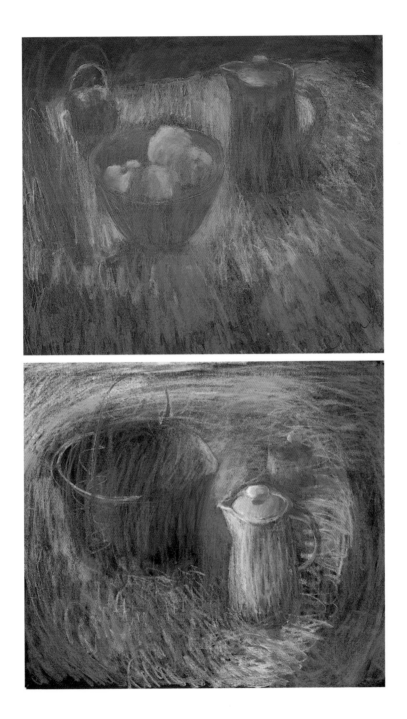

# Composition

The setting up of a still life arrangement is a meditative process for Marguerite, linked to her subconscious, and she often chooses viewpoints looking 'skywards or earthwards' which suit and even augment her mood at the time. When the viewpoint looks 'skywards', we feel a slight rush and exhilaration as we are drawn up and into the image as in 'Evening'. On the other hand, when the viewpoint looks 'earthwards' we can feel a sense of floating or falling which can be unnerving. It is also a somewhat introspective action looking down on the objects, as if we are looking deep into ourselves. Will we like what we find when we delve deep into the bowl of apples in 'Cooking Apples'?

Negative space is also important to Marguerite in her compositions because of its bearing on the emotional meaning of the image. As she says, 'space is enclosed or open', and the objects can be large in it or small, perhaps giving a sense of strength and power or shyness and vulnerability. 'The use of space in relation to the objects determines, of course, the character of the compositions. With me, the objects are gathered together quite spontaneously but with a spiritual awareness seen as a whole by a unique effect of light and colour.'

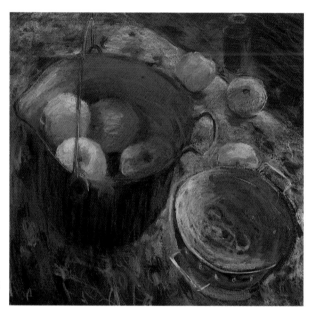

**Cooking Apples** pastel on paper **76 x 77cm**
Here Marguerite looks down on her subject, giving us a spiritual sensation of floating. There is a mood of unease created by the precarious angle of the cloth and the apples teetering on the brink which is increased by the heavy, energetic use of the pastel around the edge of the colander and on the cloth.

## golden rule

### Checking all the viewpoints

Amateur still life artists often just set out the objects they wish to paint in front of them and then set to work on the painting. But take a little time over the viewpoint. Crouch down to be on a level with the objects or slightly below them and you'll find that even the smallest items take on a more monumental, powerful aura. Look down on the objects from above and they look different again, perhaps more intriguing because you are peering into them. Move left and right and see how the negative shapes between the objects open up or close, perhaps saying something more than they did when you first looked at them. Contemplate the objects and attune yourself to them and you'll be able to put more meaning and emotion into your work.

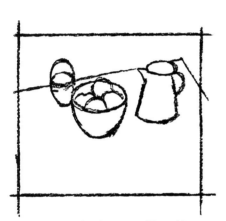

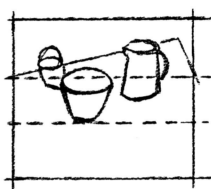

This is a very simple composition with an open structure which allows our eyes to move in and around the objects. The only pattern is provided by the artist herself through her expressive use of marks, and while the colour leaves us feeling exhilarated, the composition produces a sense of calm and release. It's like the feeling after taking a long walk on a cold or windy day.

When planning her compositions Marguerite is very much aware of the importance of the negative shapes (the areas around the main objects). Here it is the tabletop that provides most of these. It is lighter than the main objects and brightly decorated, making it more noticeable and giving it greater importance in the overall image.

It is generally agreed that placing the main objects roughly a third of the way in from the picture edges gives the most pleasing results and here all three objects touch an imaginary line a third of the way down the support. Marguerite plans her compositions instinctively, not thinking about such 'rules' as these, but it is interesting that she naturally finds the 'right' positions for everything.

# Colour

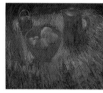

'Colour is a wonderful communicator and there are many unique colour relationships that are waiting to be expressed. I use all makes of pastel in an effort to explore the possibilities of colour. In this I find pastels inhibiting as oils have more potential for discovery through constant mixing, although it is possible to make one's own pastel sticks by buying raw pigment and mixing with gum tragacanth and chalk. Broken segments can be reconstituted in this way with beautiful greys as a result.'

### The artist's palette

Marguerite uses colour instinctively, not simply recreating the set-up in front of her but choosing hues which best express her meaning. Like most pastel artists she works with a huge range and selects colours from different brands depending on the softness and intensity she requires at the time.

## pointer

### Analogous harmonies

Instead of trying to blend colours all the time with her fingers, a torchon or a rag, Marguerite lets the viewers do some of the hard work and combine the colours in their minds, producing a much more lively, light-filled image than if the colours had all been blended. She often combines colours on an object which are adjacent on the colour wheel such as blue, violet and pink or red, orange and yellow. This is known as an analogous harmony and produces a very rich and pleasing effect.

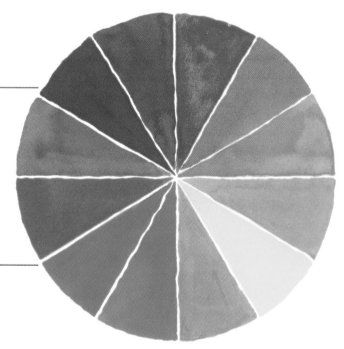

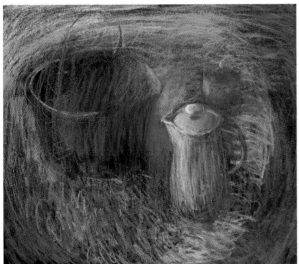

'There are many unique colour relationships that are waiting to be expressed.'

In this painting, as in others, Marguerite shows a spectacular use of colour. Although working intuitively, she adopts many of the techniques known to bring out the best in colours. For example, here the colours on the objects are analogous for a rich yet soothing harmony (see Pointer) while the relationship between the objects and the cloth is a sparky, energised one. Marguerite uses complementary colours here (opposites on the colour wheel) which are known to make each other sizzle and sing. So, for example, the yellow in the cloth enlivens the violet on the pot, while the orange enlivens the blue.

# Technique

'I draw very much with everything in mind, keeping the unity of the work going at the same time – relationships of shapes and rhythms, with tones anchored and colours perceived and responded to. Everything works together like the limbs and organs of a living body and consequently marks and lines run across and through the work, placing the components by a hidden but emphatic structure.'

## Gesture drawing

Marguerite uses a technique known as gesture drawing for her pastel work. It is a method which works particularly well with pastels because they glide easily across the paper and provide a good range of textural effects. It involves working rapidly and spontaneously to capture the impression of the subject. Feeling is put into every stroke so that the way the colour is applied expresses something about the essence of the subject or the artist's reaction to it. For example, fluid lines might express an object which is flexible, living or soft, while hard, sharp lines might imply that an object is hard and man-made. Marks can also be used to express emotional responses such as love, hate or apprehension.

Rough blending gives the apples a smooth, natural quality which emphasises their sleek, living skins and contrasts with the harder marks which indicate the man-made objects in the set-up. In this way Marguerite is putting a sense of the 'being' of every object into the picture as well as describing their physical appearances.

Notice how Marguerite uses only what is necessary to describe each subject. Pale highlights enable us to make out the lip and the lid with its rounded knob while mid-blue marks on the side, slightly lighter than elsewhere, show where the body of the pot catches the light. We can fill in the rest because we know what we are looking at.

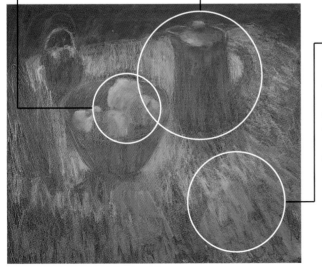

Energetic scribbles of pastel are applied in a feathering motion and their dynamic lines lead us towards the coffee pot and the other objects, directing us subconsciously towards the subject. The hot scarlet red is an advancing colour which helps bring this area up towards us while the cooler pinks at the back of the table recede slightly.

# STILL LIFE DRAWING MEDIA

For this artist the choice of objects in his still life was more or less of secondary importance. What he wanted to do was to paint the effects of light. So for the set-up he chose objects which were readily available but which responded favourably when lit dramatically from a single source. 'I was inspired to create this particular painting by studying some paintings by David Leffel and Gregg Kruetz and by the chiaroscuro work of Rembrandt. I was after a strong colour scheme but my main focus was the effects of light.'

**Lemons and Copper Pot by Alan Melson** pastel on paper **38 x 61cm**

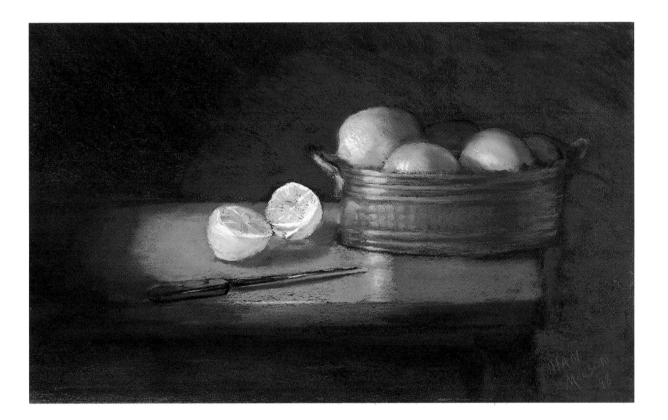

# Composition

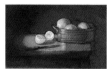

'I was playing around with set-ups and compositions one day when I was struck by the light and colours I saw on the copper pot. The lemons and knife came later. I wanted to play up some opposites in the blue of the background and the copper colours on the pot and table. The lemons happened to be in the fridge at the time and I thought that they would be very harmonious in colour with the pot. I wanted the knife coming out of the darkness a little and gave some thought to the direction it was pointing – positioning it so that it is aimed at the corner of the pot ensures that the eye is taken back around to the lemons on the table.'

It is light which takes the leading role in this picture, so Alan has designed the composition accordingly. The copper pot and lemons do not fill the support, as you might expect, but take up just about half of it, leaving plenty of space for a patch of light on the table and some strong shadows around it. It is through contrast that we see and experience things – without the darkness we wouldn't register the intensity of the light – so these shadows on the periphery of the image are of vital importance. Without them the glow of light reflecting from the lemons, table and copper pot would be dulled and the image would lose much of its impact.

'A drawing must have a power of expansion which can bring to life the space which surrounds it.'
(Henri Matisse 1869–1954)

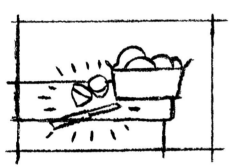 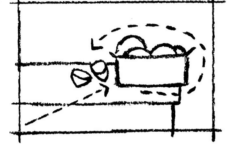 

Notice that although the weight of objects lies heavily to the right of the composition, there is no feeling of imbalance or that the left side is somehow lacking. This is because the intensity of the light is greatest on the left and creates strong contrasts which are highly attractive – almost mesmerising. These more than hold their own against the level of interest on the right.

The sharp angle of the knife catches our attention and leads us over to the copper pot. Our eyes sweep around it and over to the two lemons on the left and then on to the knife again so that we can repeat the process. By this careful orchestration of items Alan ensures that the painting retains our interest as we are led around and around it, each time noticing more and more detail and perhaps stopping to linger over certain areas that attract our notice.

Faced with this set-up, some artists would be tempted to crop off the sides and top to reduce the amount of background to be tackled. Try doing this with your hands and you'll see that the picture loses its impact. This is because by cropping off the edges we lose the dark areas which make the light areas look bright by comparison and are therefore of vital importance in the composition.

## golden rule

### Deciding what to include

Knowing just how much background to include in a still life painting can be a tricky business. As this painting shows, it isn't just a question of making the objects fill as much of the picture area as possible. One answer is to make a series of charcoal sketches or, if the items are not perishable, take a series of photographs. However, you can get a good idea of the effect by linking fingers together and thumbs together and looking through the gap in-between, moving your hands in and out to see the effect of different amounts of background. Alternatively, look through a camera with a zoom lens and simply zoom in on different compositions – there's no need to take any pictures.

# Colour

Alan usually works with three brands of pastel: NuPastel, Rembrandt and Sennelier. NuPastels are the hardest and Alan finds them best at the early drawing stage. Then he uses Rembrandt pastels for the body of the work and he finishes off with the very soft Sennelier and Schminke pastels which leave a lot of pigment on the paper to produce great intensity of colour.

Although Alan basically reproduced colours as he saw them for this picture, he also took liberties with reality when he felt the image needed it. 'I painted the colours that I saw with the exception of the purple shadow of the lemons on the table. I also used some of this colour to create the shadows on the lemons themselves along with some darker yellow ochre and siennas. The reflected light colour on the right side of the pot was also invented and I took some liberties with the shadow under the table. I wanted to harmonise the painting so I included some of the same dark blue in the shadow on the table.'

**The artist's palette**

Despite the relatively limited colour scheme Alan used quite a large number of pastels for this image from his range of blues, yellows, violets and browns. Even so he made sure that the colours were balanced by repeating them around the image. For example, the blue and violet in the shadows of the lemons on the table are repeated on the front of the table and in the shadow under the top.

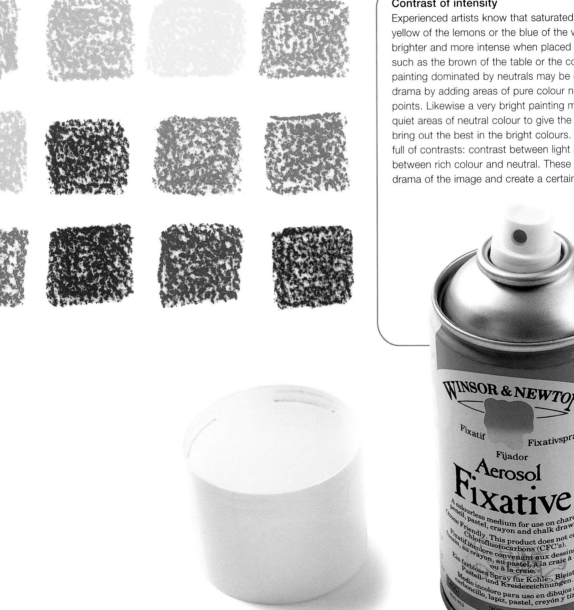

pointer

**Contrast of intensity**

Experienced artists know that saturated colours, like the yellow of the lemons or the blue of the wall, appear brighter and more intense when placed next to neutrals such as the brown of the table or the copper pot. A painting dominated by neutrals may be given a flash of drama by adding areas of pure colour near the main focal points. Likewise a very bright painting may require some quiet areas of neutral colour to give the eye a rest and to bring out the best in the bright colours. Alan's picture is full of contrasts: contrast between light and dark and between rich colour and neutral. These heighten the drama of the image and create a certain excitement.

# Technique

'I worked this painting using the sight size method. You can't beat it for judging proportions, colours and values but you will get tired of walking. I started by drawing in the composition with NuPastels and then switched to Rembrandts to fill in the colours and establish the tones. After painting the entire piece I sprayed the painting with fixative. Then I went over the entire surface again with Sennelier pastels and a few Schminkes until I had produced the texture and painterly appearance I was after. No fixative was applied after completing the work because it darkens the colours a great deal.'

## shortcuts

### Working sight size

Alan worked sight size for this painting. To do this you need a reasonably large painting area. Set up the still life arrangement next to the easel rather than in front of it. Walk back to a fixed position – Alan goes back about three metres – from where you can see both clearly and mark the spot. Next you place a stroke on the support to represent something in the set-up and then return to your viewing position to compare it to the subject in the still life. The stroke should be the same size as the item it represents in the set-up. Continue in the same way to complete the painting. This is very difficult at first because you feel as if you are working blind, but as you build up your strokes, which act as reference points, it becomes easier.

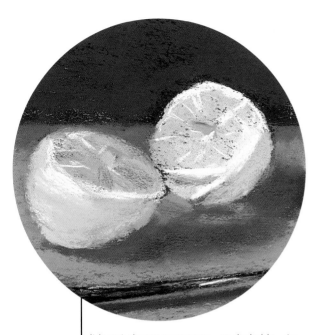

It is not always necessary – or desirable – to go to great lengths to render every detail of an item. Look at how Alan has recreated the cut edge of the lemons on the table with a few carefully considered strokes of pale yellow.

As Leonardo da Vinci (1452–1519) pointed out, 'the surface of every opaque body shares in the colour of the surrounding objects'. If you look at the colours on the table and copper pot you will see that many are repeated as each is reflected in the other and each picks up some colour from the lemons. These colours are not heavily blended but left to stand, creating a lively surface.

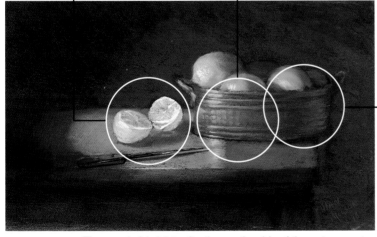

The wonderful violet reflection on the side of the pot was not in the original set-up but it enlivens a shady area and brings out the richness of the blue background. Notice that the same colour is repeated in several areas, such as the end of the knife and in the shadows of the lemons in the copper pot. This helps harmonise the image and encourages our eyes to look around the composition from one application to the next.

# STILL LIFE DRAWING MEDIA

Richard was inspired to draw this picture by the abundance and fascinating forms of the chillies he saw. 'Still life painters from the beginning have painted the abundance of the harvest and this picture follows that tradition but with my own direct twist. I had a vision of a few chilli peppers coming out of a mass of chillies. Using colour and repetition, detail and lack of it, the viewer is brought intimately onto the table where the chillies have been randomly strewn.

'Much of my inspiration generally is derived from everyday life – there is beauty all around us that can be found in the simplest of things. For me, these things can be either natural or man-made. In particular I have a lot of fun painting fruit and vegetables because of the variety of colours and shapes. I think that a lot of people can identify with food very readily and so there is no need to paint the object photographically – my job is depicting it expressively with mystery and whimsy.

'The danger with still life paintings is that they can be very static and sometimes boring, but this forces you to create an interesting painting. It reminds me of the jazz music which I enjoy so much. When you listen to live music the product has a lot to do with how the musicians are feeling, their energy levels and so on. They may play the same song night after night but it sounds different each time, depending on their inspiration. Even though I have painted many pictures of apples, each is different depending on my inspiration for that day.'

**Chilli Harvest by Richard D Wieth** pastel on paper **18 x 38cm**

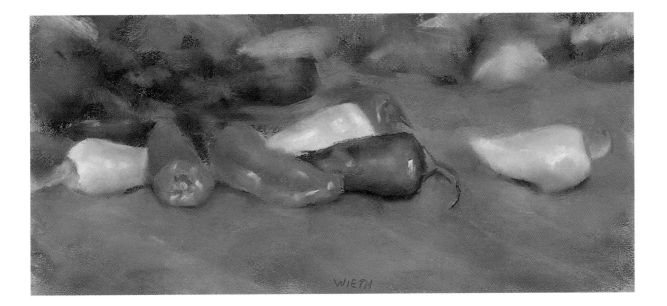

# Composition

'No one is an artist unless he carries his picture in his head before painting it, and is sure of his method and composition.'

(Claude Monet 1840–1926)

'I don't have a set formula for setting up a still life; it really depends on what I have on hand to paint, although I do like some drapery or background colour. What I look for when choosing objects for the still life is colour and shape. I love bright colours with contrasts and interesting shapes – tall, round, strange, patterned, natural or man-made.'

Despite his love of variety, Richard doesn't allow his pictures to get too busy. He is careful to focus on just one or two objects, letting the others take on supporting roles. 'As in an opera, there can be many on the stage but just a couple of stars or leads. As my mentor, Ramon Kelly says, "if all the actors on the stage were screaming at the same time you would not get the message". The putting together of objects has to be harmonious to the whole.'

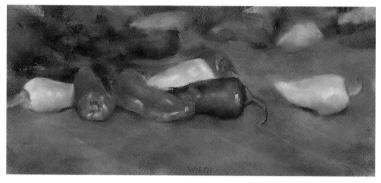

'For "Chilli Harvest" I wanted to show abundance, so I just dumped the chillies on the table. I only had to arrange a few of the front ones so they wouldn't be all facing in the same direction or look too repetitious.'

## golden rule

**Using objects of a similar size and shape**

Most artists select at least some items for their set-up which have radically different shapes or sizes to offer visual variety and to help lead the viewer around the picture plane; it can be difficult to arrange similar objects in an interesting composition. Working close up is often the key because we start to see the subtle differences which make objects – like people – interesting. Richard places his chilli peppers at different angles so that we can see the variety of form and colour. Look also at 'Three Garlic Bulbs' by Martin Huxter (page 60). Here the garlic bulbs are laid out in a neat row so we can study and compare their every contour. The two pictures have radically different results because of each artist's unique approach and mood at the time.

Richard has a clever way of collecting references for his still life pictures or, 'stealing the still lives of everyday life', as he puts it. 'Going through an antique market I will take snapshots of how things are laid out on the tables – still lives set up by the dealers can be beautiful. Farmers' markets and flower markets are other opportunities to accumulate still life reference.'

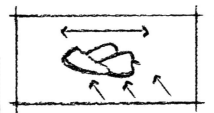

The diagonal lines of the wooden table draw our eyes as if along a path to the chillies at the front. Here the medley of colour and shape keeps our attention for a while until we are drawn along the line of the yellow chilli up to the top right-hand corner of the composition where we can contemplate the colours and forms of the chillies at the back.

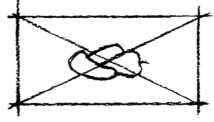

Richard placed the foremost green chilli in the very middle of the image. Like the lead in a play, this chilli takes centre stage and draws the eye even though it is placed in a line with several other chillies. This shows how important the centre of a picture can be in a composition as it always draws our attention.

Laying out the main 'characters' in a central line across the support is a brave move because it can create a static feel. However, because the chillies are all at different angles and not grouped evenly our eyes are encouraged to dance about and the image does not seem static in any way.

# Colour

Like most pastel artists Richard has a huge range of colours, some so well-used that it is no longer possible to tell which brand or even which colour they are. 'My pastel palette is huge and I couldn't specify exact colours in terms of names. I use colours that feel right and tend to mix them on the paper and grey everything down until the end. I do, however, use pure colour for the final shots or strokes.

'I think that colour is one of the keys to an exciting still life. I will add colours for impact and expression, but I think that it is important to work all over the painting so colours don't look like orphans.'

# pointer

**Coloured grounds**

Most pastel work is carried out on a coloured ground (paper). The colour of the paper can set the colour bias (warm or cool) or simply the tonal value (light, medium or dark). It can also stand for a dominant colour in the picture such as the green of a clutch of apples. Sugar paper can be bought in a wide range of neutral colours and in some bright colours while velvet card tends to come in more limited ranges. If you can't find the colour you want, you can work on stretched watercolour paper washed with whatever colour you choose. Remember, though, that the colour of the ground will affect the way we see the colour of the pastels laid on top. It's always worth trying out your colours on a scrap of your chosen paper before you use each one.

'I tend to use Rembrandt soft pastels for the majority of the painting, preferring Sennelier pastels for the final applications of pure colour. For any details or sharp lines I use NuPastels.'

# Technique

'I like to start by sketching out the composition very basically with a combination of yellow ochre and cobalt blue. Then I block in all of my middle tones, again very loosely. Next I add my darks, tightening things up as I go. Lastly I add my lights, again tightening things up. With this method I can really take things as far as I want, from very loose and impressionistic to photorealistic. At the end I like to add some last highlights and shots of pure colour.'

## 'I love to invent and don't always paint exactly what I see – we have cameras for that.'

### shortcuts

**Creating sfumato in pastel**

Sfumato is a visual quality in a painting which is most often associated with Leonardo da Vinci (1452–1519). It refers to a smoke-like, hazy look achieved by allowing tones and colours to merge into each other, having very little reliance upon line. Richard uses it frequently, notably for the background chilli peppers in his picture. It can be achieved by blending with a finger, soft brush or torchon (tightly rolled stick of paper), by scumbling one colour on top of another or by lightly erasing areas with a kneaded eraser or a piece of fresh white bread.

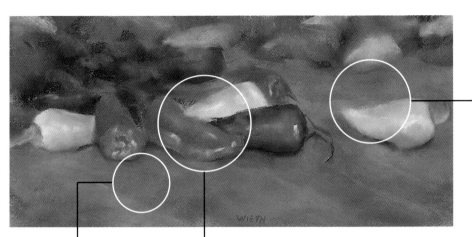

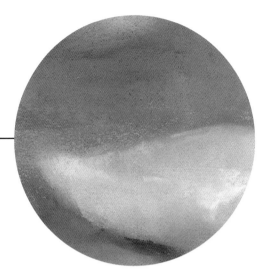

Using strokes of pure colour for the final 'shots', including the white highlights on the glistening skins, Richard instils his picture with vibrancy and energy.

Notice how some areas of the picture are sharp while others are fuzzy. Richard likes to do this not just for variety of line and texture but because, 'if everything has the same edges it will look stiff and cut out. I also like to leave strokes showing – it is a painting, after all, and I want it to look painted.'

With a liquid painting medium it is all too easy to paint background sections as matt, dead areas, but with sticks of colour the temptation is probably to over-embellish. Richard has used his pastels with a restrained, relaxed hand to give the table enough variation to occupy the eye but not so much that we are drawn away from the leading characters, the chilli peppers.

# STILL LIFE DRAWING MEDIA

'I came to still life from a background of abstract painting and I still use the same ideas and processes as I did then. I organise the shapes on the picture surface by looking at form and structure and studying how they affect each other. I want my pictures to work on an emotional level, but also to be highly structured with these two apparent opposites enhancing each other. The good thing about working in still life is that you are able to build a composition that works just in the way you want it to. The difficulty is trying to prevent it from looking artificial and staged.'

For 'Egyptian Cloth' Peter arranged the fruit, flowers and cloth so he could, 'set off the real objects against the flat shapes of the patterns'. His use of pattern is partly inspired by Eastern and Islamic art while his attention to detail owes much to the standards set by Dutch 17th-century artists.

**Egyptian Cloth by Peter Woof** coloured pencil on watercolour paper **48 x 41cm**

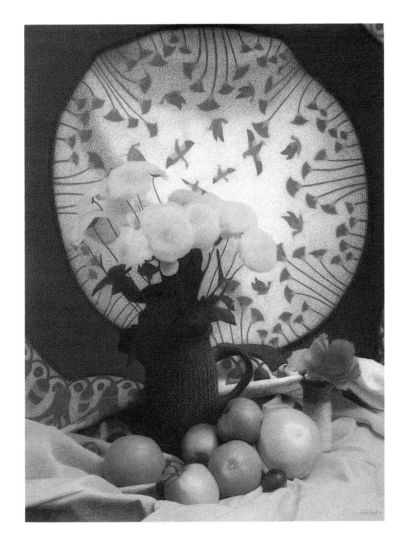

# Composition

Peter starts by arranging an assortment of likely objects for his still life picture. Once he is fairly happy with it, 'I examine it from many different angles to see how the different shapes and elements work together. Then I select what I consider to be the most important elements. With "Egyptian Cloth" it seemed to be a composition that naturally fell into two parts: the patterned cloth at the back and the orange cloth with the objects on it, both parts being linked by the vase of flowers. I liked the cloth acting as a background with a very strong circular shape.'

**Green Bowl** coloured pencils on watercolour paper **38 x 56cm**
A wide panoramic format is unusual and therefore draws attention whatever the subject. Here it is made even more striking by the fact that the subject matter does not fit naturally into the shape – the bowl has to be 'sliced off' at the top and bottom. This actually focuses attention more fully on the two apples in the centre of the image since our eyes are not drawn away by the strong circular form of the bowl.

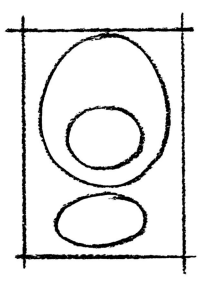

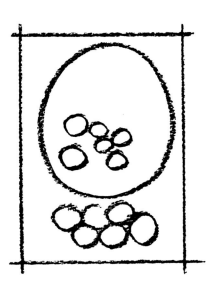

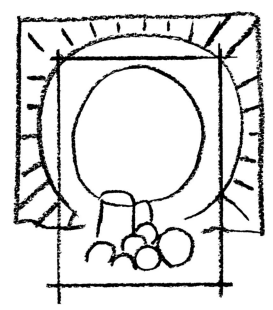

This is Peter's original set-up. Peter examines it from several angles before deciding on the best composition.

Echoing and reinforcing the circle on the background cloth are the two ovals of the flowers and the arrangement of fruit. On looking more closely you will see that further spheres and ovals break down the composition – those of the flower heads, the fruits and horse chestnuts.

By narrowing his field of view to omit most of the outer border on the cloth Peter realised that he could use the blue colour of the middle border as a flat background. 'This gives much greater emphasis to the circle on the fabric which in turn gives more emphasis to the flowers that break this circle.'

## golden rule

**Circles in compositions**

A single circle in an image can become a bit of a trap because once we have been drawn in along that path our eyes travel continuously around it until we finally pull away, often with such force that we don't notice other elements in the painting. A series of overlapping circles or ovals, however, can be very effective because our eyes are allowed to move from one to another and can therefore explore much more of the picture area. This also creates a more leisurely rhythm than a single circle, making it ideal for contemplative subjects.

# Colour

'The colours I use are the colours as I see them. This is because I want to give a sense of the realism of the objects themselves and the set-up. However, I still choose hues that will work on an emotional level and the placing of these in the picture is critical in this respect. Therefore, in the setting up of a still life the colour of each of the different elements has to be given great thought.'

## The artist's palette

Peter always works in coloured pencil, using Berol Karisma pencils exclusively as, 'they are extremely soft, the colour is very strong and they are produced in a wide range of hues'. These qualities ensure that Peter can produce sharp results even when working on the intricate patterns of a bowl or shawl – vital for anyone who works with such attention to detail.

canary yellow     yellow-orange     vermilion

mineral orange     dark green     ultramarine

dark grey     scarlet

# pointer

**Optical mixing**

On smooth paper such as HP watercolour paper, optical mixing can be achieved by cross-hatching – applying strokes first in one direction and then at right angles. Work first in one colour, then overlay a second hue, filling in some of the white areas. When using textured paper such as Rough watercolour paper, optical mixing is made a little easier because the surface of the paper naturally breaks up each application of colour. Apply the lighter colour first, then the darker colour on top, varying the pressure and concentration of the darker hue to produce transitional tones. With Not watercolour paper you can use either technique, depending on your preference.

As with pastels and other coloured drawing media, the hues of coloured pencils can't be mixed as such, so artists need a fairly large range of colours if they intend to produce realistic results. However, colours can be laid next to each other in tiny dots or strokes so that from a distance they blend in the eye – useful for shading and shaping items. This is known as optical mixing (see Pointer). The same colour can also be overlaid to produce gradations of tone.

In 'Egyptian Cloth' Peter used plenty of yellow-orange and canary yellow on the flowers, ultramarine on the background, mineral orange in the foreground and scarlet and vermilion on the birds. The vase was built up in dark grey and dark green.

# Technique

Peter starts by taking a series of photographs of his set-up which he then uses to work out the composition. Once he has the idea mapped out in his mind he makes an outline drawing in pencil on his chosen paper. Instead of working over the whole picture area, building it up gradually as one might in oils, watercolour or acrylic, say, Peter decides where to begin and then completes a small area before moving on, 'referring back to the first area for colours, and repeating the process until the entire picture surface is covered'. Once the whole picture area has been worked Peter makes a few adjustments, but, 'not to any great extent'. It may sound an unusual system, but Peter points out that it was also adopted by the artist Stanley Spencer whose paintings can now only be acquired by the richest clients.

   The 640g Not watercolour paper which Peter works on has a 'nicely textured surface' which he finds complements the way he uses the pencil. 'Each colour in the picture is made up of about four or five different colours laid softly on top of one another, with the colour becoming denser and darker with each layer so that I am working back from the highlights into the shadows. Along with the colours I also have to add greys to get the right tones and I keep putting layer on layer until I am happy with the finished result. I use a putty rubber to lift off areas of colour and also a knife to scrape off unwanted sections.'

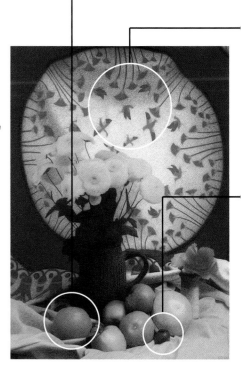

'I move the pencil across the paper with a sweeping action but as I get down to the fine detail I use the point of a pencil.'

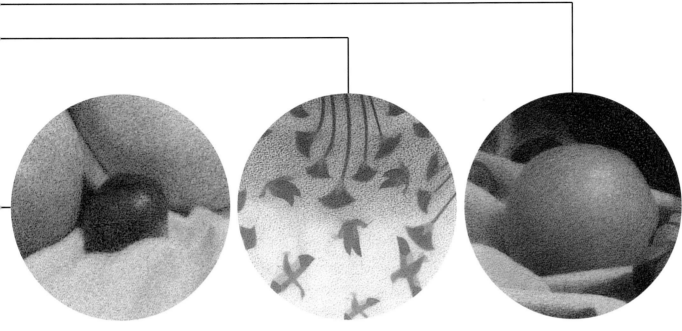

Working gradually, as an etcher would, Peter builds up tones by applying colour layer on layer. It is a painstaking process – this picture took Peter about 150 hours to complete.

Peter uses greys to help produce the right tones for the shadows. In his skilful hands these enable him to mould his objects until they seem truly three-dimensional.

Highlights like this need to be left blank from the start. However, if necessary they can be brought back using a putty rubber or by scraping gently with a knife (see Shortcuts).

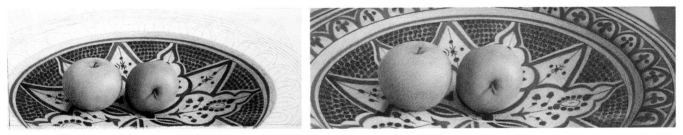

Peter's unusual technique involves completing the picture section by section, rather than building up the whole image gradually. This means he is committed to a style and level of detailing from the start and it demands an accurate and systematic way of working.

# Portfolio

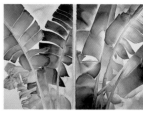

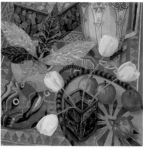
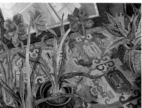

GAIL BRODHOLT has a BA Honours degree in Fine Art from Kingston-upon-Thames College and has worked professionally as a painter ever since. She has exhibited widely and her work is held in private collections both in the UK and abroad. She can be contacted at her studio:
15b Foxgrove Avenue
Beckenham
Kent BR3 5BA
UK
or by email:
gail_brodholt@hotmail.com
or visit her website:
http://website.lineone.net/
~gail_brodholt/

(pictures)
Apples and Tulips, detail
Apples and Tulips
Still Life and Agave

CAROL CARTER is an established St Louis-based painter working primarily in large-scale watercolours and acrylics. She has exhibited extensively both regionally and nationally, including 15 one-person exhibitions and numerous invitational and group exhibitions. Her work is represented in many public and private collections including those of Blue Cross/Blue Shield; Boatmen's National Bank; Citicorp; Leonard Slatkin; Price University; and Utah State University amongst others. Carol is represented by Peter Barlow Gallery in Chicago. To view more of her work contact her at:
4450 Laclede Avenue
St Louis
MO 63108
USA
or visit her website:
www.carol-carter.com

(pictures)
Small Floral
Iris
The Grand Bananas

TERENCE CLARKE was born in Manchester, UK and has a BA Honours degree in Fine Art from Coventry University and an MA in painting from the Royal College of Art. He has exhibited his work at the National Portrait Gallery, London; Montpellier Gallery, Cheltenham; and more recently at the City Gallery, London; Thompsons of Dover St, London; and Paton Gallery, London. To see more of his work contact him at:
60 Callow Hill Road
Alvechurch
Worcester B48 7LR
UK
or email him at:
terence.clarke@lineone.net

(pictures)
The Punnet of Strawberries
Two Pears

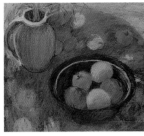

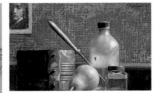

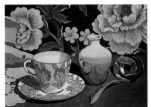

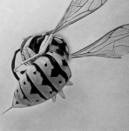

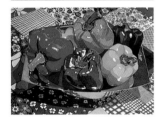

MARJORIE COLLINS was born in Chicago and trained at the University of Michigan where she obtained a degree in Fine Art. She moved to England in 1975 but continues to exhibit her work in the USA as well as in England. She has exhibited at the Royal Academy Summer Exhibition; the Hunting Prizes; Singer & Friedlander/*Sunday Times* Watercolour Competition; the Royal Institute of Oil Painters; the Royal Institute of Painters in Watercolour; and the Royal Watercolour Society. In 1992 she won the Daler-Rowney Purchase Prize for a floral still life and in 1999 she won the Winsor & Newton Grand Prize Award for a still life in watercolour. Her paintings have also been shown in a number of magazines and books. Contact her at her studio:
28 Hayward Road
Oxford OX2 8LW
UK
Tel: +44 (0)1865 552 591
or email: marjorie@painthouse.
fsnet.co.uk

(pictures)
Mirror Image, detail
Summer Blues
Peppers on Patchwork

MARGUERITE ELLIOTT trained and studied Fine Art at Brighton College of Art and the Royal Academy Schools, London. She paints in oils and pastel, usually taking the interior as her subject including objects or figures in the interior and also painting landscapes. She worked in Italy when she first graduated at the British School in Rome. 'Drawing from archaeological objects gave me more of an understanding of the meaning and essence of household domestic vessels.' Marguerite has exhibited in Italy and the UK, including at the Royal Academy Summer Exhibition. Her work is in private and public collections in the UK and USA. At present she is Artist in Residence at Chester Cathedral, Chester. Her work can be seen at the Duncan Campbell Gallery or you can telephone her on:
+44 (0)1244 320 024

(picture)
Summer Fruit

MARTIN HUXTER studied Art at Southend College of Technology and Trent Polytechnic, UK. He has held a number of solo shows and participated in numerous group exhibitions in the UK and in Vienna, Austria where he now lives and works. These include 'Natural Selection' at the Stiftsmuseum Klosterneuburg, Austria; 'Nightingale Suite' at the Vienna International Centre, Austria; John Moores Liverpool Exhibition 16 where Martin was a prize winner; the BP/Amoco Portrait Award Exhibition at the National Portrait Gallery, London; 'Drawings For All', Gainsborough's House, Sudbury, Suffolk; the Piccadilly Gallery, London; and the East West Gallery, London. His work is held in private collections in the UK, USA, Germany and Austria. To see more of his work, contact him at:
Tiefendorfergasse 12/1/4
A-1140 Vienna
Austria
or:
295 High Street
Great Wakering
Essex SS3 OHZ
UK

(pictures)
Dried Toad
Wasp on a Red Background

ADAM KATSOUKIS was born in Athens, Greece but went to Florence in Italy to study Art at the Florence Academy of Art. His tutor was strongly influenced by the 19th century academic painters so his training was based on the system used by the French Academies and Ateliers of the last century. Adam now lives and works in Florence but travels widely in Europe in order to study the work of other artists. His paintings are held in private collections in Europe and the USA. Contact him at:
Piazza Ravenna
350126 Firenze
Italy

(pictures)
Portrait of an Oriental Woman
Still Life with Bottle and Pear
Self-portrait

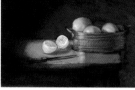

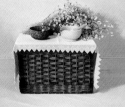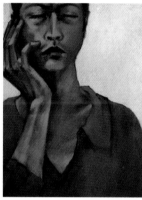

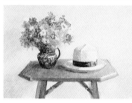

ALAN MELSON paints both portraits and still lives in oil and pastel. He is an admirer of both the Dutch Masters and Impressionists. He started painting seven years ago and paints still lives and portraits from life. He is now represented solely by his website at Art-Wave.com He seeks a variety of subject matter and also paints landscapes and figurative work. He can be reached via the website and also by contacting him at his home studio in Cartersville, Georgia, USA.

(pictures)
Lemons and Copper Pot, detail
Lemons and Copper Pot

JOSEPH O'REILLY was born in Huddersfield, UK and has a First class Honours degree in Fine Art from Sheffield Polytechnic of Art & Design. He has held several one-man exhibitions in locations around the UK including at the Piccadilly Gallery, London, and participated in numerous group exhibitions both in the UK and abroad. These include the 'Discerning Eye' exhibition at the Mall Galleries, London; the Hunting Arts Prize Exhibition at the Royal College of Art, Bath; the International Contemporary Art Fair, Basel, Switzerland; and 'David Hockney, Joseph O'Reilly, Russell Morris' at Vvije Universiteit, Amsterdam. His paintings are held in public and private collections in the UK, the Netherlands, USA and Australia. Contact him at:
9 Bank View
Mytholm Steeps
Hebden Bridge
West Yorkshire HX7 6BX
UK
Tel: +44 (0)1422 842 854

(pictures)
Still Life on a Hamper
Still Life with Hat and Flowers

BEVERLEY SCHOFIELD has a degree in Fine Art and a post-graduate degree from Birmingham University and has taught art in schools and colleges for ten years. She also runs life classes and has organised workshops yet still manages to paint in her studio and exhibit at various locations. Contact her at:
11 Albany Terrace
Worcester WR1 3DU
UK

(pictures)
Apple Study
Figure on a Gold Background

BARBARA STEWART studied at York School of Art and Leeds College of Education in the UK. She is a member of the RBSA (Royal Birmingham Society of Artists), the RWA (Royal West of England Academy) and the PS (Pastel Society). She has had several one-woman exhibitions in Leicester and Devizes and participated in numerous group exhibitions: the Royal Birmingham Society of Artists; the Royal West of England Academy, Bristol; and The Mall Galleries, London. Her paintings are held in private collections in the UK and abroad and at the Royal West of England Academy. Barbara has won numerous awards including prizes from Daler-Rowney, Winsor & Newton, Unison and Inscribe. Contact her at:
29 Meadowcourt Road
Leicester LE2 2PD
UK

(pictures)
Still Life in Charnwood, detail
Shapes of Polperro
First Encounter

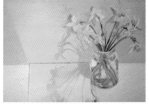

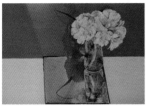

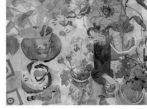
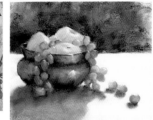

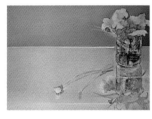

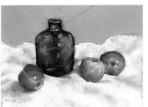

GERARD TUNNEY studied at art college before setting up his own studio practice. Most of his recent work has been influenced by theatrical residencies with the Birmingham Royal Ballet, Opera North and Northern Sinfonia. For Opera North he painted a series based on Mozart's 'The Magic Flute' to coincide with their 1998 tour. These residences have resulted in exhibitions in theatres, businesses and other venues. His work can be seen at his studio:
23 Peel Street
Sunderland
Tyne and Wear SR2 8ED
UK

(pictures)
Daffodils and Yellow
Background
Pansies and Red Background
Pansies and Green
Background

PAMELA SCOTT WILKIE has a First class Honours degree in Fine Art from Reading University. Her paintings, prints and limited-edition books are widely exhibited and have been bought for a number of public collections including the Victoria & Albert Museum, London; the University of California, Santa Barbara; the Rijksmuseum, Netherlands; and the Australian National Library. Her first major solo show was held at the FAR Gallery in New York, USA, in the 1960s. Work was also included in a group show at the Museum of Contemporary Art in Boston, Massachusetts. Since then she has exhibited her work mainly in the UK and France. Contact her at:
Combe Lodge Studio,
Foley Terrace
Malvern
Worcestershire WR14 4RQ
UK

(pictures)
Bowl with Fruit, detail
Lemon Yellow
Gold on Blue

JENNY WHEATLEY RWS NEAC has a BA Honours degree in Fine Art and Printmaking from West Surrey College of Art & Design. Exhibitions include the RA Summer show, the Royal West of England Academy, Hunting Group Art Prize and British Contemporary Watercolours. Her one-person shows have been held around the country including at the Bourne Gallery, Reigate, Jerram Gallery, Salisbury and City Gallery, London. Her paintings are held by British Gas; British American Tobacco; ICI; and Kent County Council, amongst others. She can be contacted at:
Bristol House
Portloe
Truro
Cornwall TR2 5RG
UK

(pictures)
Table Conversation
Floral Display

RICHARD D WIETH is a member of the American Artists' Professional League, the National Oil and Acrylic Painters Society and Gilpin Artists' Association. He has participated in many national and international shows including Salmungundi Club Exhibition, New York; Pastel Society of America Regional Show, San Francisco; and the Heartland Pastel Exhibition 2000, Merriam, in the US. His work has been published in 'Art of the West' and Art West Studios Greeting Cards, and he has won several awards including second place at the Heartland Art Exhibition 2000. To see more of his work contact him at:
P. O. Box 564
Black Hawk
CO 80422-0564
USA.
Tel/fax: +1 (303) 582 3425
Email: wieth@worldnet.att.net

(pictures)
Fruit Bowl
Apple Brandy

PETER WOOF was born in Liverpool in 1956 and trained first at Wigan Art College, then at City and Guilds of London Art College and finally at the Royal Academy Schools for postgraduate studies. He was a prize winner at the 1980 Royal Academy Student Show. To date he has had five solo exhibitions and has shown regularly at many galleries in Britain and abroad, including the Mall Gallery, London. He has also had five drawings reproduced as limited-edition prints, including 'Egyptian Cloth'. See his work at:
Artifex Gallery
Weeford Road
Sutton Coldfield
West Midlands B75 6NA
UK
Contact him at:
107 Stirling Avenue
New Cubbington
Leamington Spa CV32 7HW
UK

(pictures)
Still Life with Apples
Blue Jar

# Glossary of Colours

Here is a rough guide to the different qualities of paint colours used by the artists in this book. Note that paints vary from brand to brand and from medium to medium so always check the manufacturer's descriptions of the paints. For best results use a good brand of artists' quality paints such as those by Winsor & Newton. Manufacturers are constantly improving and updating their ranges, and although it is satisfying to use the same colours as the Great Masters of old, many of the modern colours are far superior in terms of handling and lightfastness, so don't get stuck in a rut – try something new.

**ALIZARIN CRIMSON** – popular violet-red; transparent; oil colour can crack if it is applied thickly; watercolour is prone to fading when applied thinly; not totally lightfast; consider quinacridone red or violet as an alternative.

**AUREOLIN** – also called cobalt yellow; warm yellow, giving clear washes; transparent; permanent; staining colour.

**BURNT SIENNA** – clear earth colour made by heating raw sienna; similar to Indian red; transparent when very diluted, opaque with less dilution; absolutely lightfast.

**BURNT UMBER** – made by roasting raw umber; transparent when very diluted, opaque with less dilution; absolutely lightfast; fairly powerful tinting strength.

**CADMIUM LEMON** – the lightest, coldest yellow; greenish; very lightfast; quite strong tinting power.

**CADMIUM ORANGE** – intense bright orange; opaque; lightfast; fairly powerful tinting strength; used by the majority of artists in this book.

**CADMIUM RED** – bright, warm red; opaque; totally lightfast; good tinting strength.

**CADMIUM RED DEEP** – similar to cadmium red in quality but a deeper colour.

**CADMIUM YELLOW** – clean and bright mid-yellow; opaque; lightfast; highly reliable.

**CERULEAN BLUE** – bright greenish blue; opaque; tends to granulate in watercolour; lightfast; quite low tinting strength.

**CHROME YELLOW** – warm, bright yellow; opaque; permanent.

**COBALT BLUE** – originally derived from crystals; transparent; lightfast; weak tinting strength.

**COBALT TURQUOISE** – blue-green; fairly opaque; lightfast.

**COBALT VIOLET** – available in light or dark versions; pale violet colour which leans towards red or blue depending on the manufacturer; transparent; excellent lightfastness; weak tinting strength.

**FRENCH ULTRAMARINE** – see ultramarine.

**HOOKER'S GREEN** – a mid green which varies in colour and quality from brand to brand.

**INDIAN YELLOW** – originally derived from the urine of cows fed on mango leaves; varies in quality from brand to brand from lightfast to a paint which fades rapidly; fairly transparent.

**INDIGO** – very dark, inky blue; originally derived from the leaves of a plant (Indigofera Tinctoria); transparent as an oil, opaque as a watercolour; permanent.

**LAMP BLACK** – slightly bluish black; basically made from soot which has been heated to remove any oil; opaque; extremely strong tinting strength; totally lightfast.

**LEMON YELLOW** – see cadmium lemon.

**LIGHT RED** – earth colour; generally opaque; absolutely lightfast.

**MAGENTA** – warm, pinkish violet; transparent; lightfast.

**MARINE BLUE** – FW Acrylic Artists Ink colour from Daler-Rowney; elegant navy blue; transparent; permanent.

**MAUVE** – similar to ultramarine violet but slightly darker; as a watercolour it granulates; transparent; permanent.

**MONESTIAL BLUE** – see phthalo blue.

**MONESTIAL GREEN** – see phthalo green.

**NAPLES YELLOW** – usually a delicious blend of cadmium yellow and white; opaque; lightfast.

**NEW GAMBOGE** – deep yellow; genuine gamboge comes from tree resin and isn't permanent but new gamboge is; transparent.

**PERMANENT ROSE** – bright pink; usually transparent; lightfast; staining colour.

**PHTHALO BLUE** – short for phthalocyanine blue; intense mid-blue; extremely strong; transparent; lightfast; also sold as monestial blue or Winsor blue.

**PHTHALO GREEN** – short for phthalocyanine green; vibrant blue-green, similar to viridian and equally strong; transparent; lightfast; also

sold as monestial green or Winsor green.

**PHTHALO TURQUOISE** – rich blue-green; transparent; lightfast.

**PRIMARY RED** – available as a pigment from Green & Stone, London; hot red like vermilion.

**PROCESS BLUE** – said to be as close to primary blue as possible; essentially cobalt blue.

**PROCESS RED** – said to be as close to primary red as possible; available as a pigment from Green & Stone, London.

**QUINACRIDONE VIOLET** – bright violet-red; transparent; lightfast; brushes out smoothly and mixes wonderful clear pink-violets when combined with ultramarine; sometimes sold as permanent rose; a fine, reliable alternative to the popular but less reliable alizarin crimson.

**RAW SIENNA** – soft yellow earth colour, similar to yellow ochre; good opacity; absolutely lightfast.

**RAW UMBER** – warm brown earth colour; cool, greenish brown; can darken over time; lightfast.

**RED IRON OXIDE** – one of a group of very similar colours based on synthetic or artificial iron oxides including Indian red, Mars red, English red and Venetian red, which vary according to manufacturer; usually fairly opaque; lightfast.

**SAP GREEN** – soft, earthy green; originally produced from buckthorn berries; lightfastness varies according to brand but may only be moderate.

**SEPIA** – dark, black-brown; originally derived from the ink sac of cuttlefish or squid; lightfastness varies according to brand.

**SOLFERINO LAKE** – brilliant pink pigment available from Green & Stone, London.

**TITANIUM WHITE** – inexpensive bright white; not as toxic as flake white; very opaque; absolutely lightfast.

**TRANSPARENT RED OXIDE** – deep red-brown; transparent; lightfast.

**TRANSPARENT YELLOW OXIDE** – earthy yellow; transparent; lightfast.

**ULTRAMARINE** – wonderful bright violet-blue; originally derived from lapis lazuli and therefore highly prized; transparent; absolutely lightfast; good tinting strength.

**VANDYKE BROWN** – cold, earthy brown; the true pigment comes from decomposed vegetable matter and isn't lightfast, but modern paints sold under this name are usually made from modern materials and vary from totally lightfast to moderately so; generally transparent.

**VERMILION** – a bright, intense orange-red, similar to cadmium red; only moderately lightfast as a watercolour, better as an oil or acrylic.

**VERMILION HUE** – very similar to vermilion but usually more reliable; lightfast.

**VIRIDIAN** – excellent, strong, clear bluish green; lightfast; transparent; stains overlaid colours readily.

**WINSOR GREEN** – another name for phthalo green.

**WINSOR GREEN YELLOW SHADE** – Winsor & Newton oil or watercolour; strong mid-green; quite transparent; lightfast.

**WINSOR RED** – slightly warmer than cadmium red; transparent; permanent; staining as a watercolour.

**WINSOR VIOLET** – Winsor & Newton oil or watercolour; bright; transparent; staining colour; lightfast.

**YELLOW OCHRE** – muted yellow earth colour; generally strong; similar to raw sienna but more transparent; absolutely lightfast.

# Glossary of Terms

**ACRYLIC** – a fast-drying, modern painting medium made by combining pigment with acrylate resin. It handles like oil paint or alkyd when thick and like watercolour when thinned, and it dries quickly to a water-resistant finish which does not yellow. Acrylics are water-soluble when wet so they are often adopted by painters who work in mixed media. Liquid acrylics have the quality, feel and colour depth of ink.

**ALKYD** – a modern type of oil paint that dries much quicker than oil. It may be used on its own or combined with oil paint to speed the drying time.

**BINDER** – the substance which binds the pigment together to make paint such as gum Arabic or linseed oil.

**BLENDING** – the method of combining two colours where they meet so that it is impossible to tell where one colour ends and the next one begins. Blending is usually done with a brush, rag or finger. With pastel a shaped roll of paper called a torchon can also be used. It is especially useful for working on small areas.

**BROKEN COLOUR** – where colours are applied next to each other in small amounts so that from a distance they appear to mix. The result is a shimmering effect which captures the qualities of light very well.

**COMPLEMENTARY COLOURS** – opposites on the colour wheel. Examples are red and green; yellow and violet; blue and orange. When placed together complementary colours seem to make each other look more vibrant, but when mixed they create soft neutrals. Compare with Split Complementaries.

**DRYBRUSHING** – the method of skimming a small amount of undiluted paint over the surface of the support to leave a broken trail of colour.

**EARTH COLOURS** – pigments derived originally from coloured earth. These include terre verte, a soft green, and yellow ochre, sienna, umber and Indian red which range in colour from soft yellow to brown.

**EGG TEMPERA** – a traditional paint made by mixing fresh raw egg yolk with pigment and oil. The paint dries within seconds of touching the paper so it suits artists with a meticulous approach. Today ready-made tempera is available, although most artists who use the medium still prefer to make their own. This is perhaps the most durable of all painting mediums.

**FAT OVER LEAN** – refers to the traditional technique of starting an oil painting with paint that has been thinned with turpentine or another thinner, then progressing to pure paint or paint mixed with oil for the final layers. This means that the first layers dry quickly and corrections are easy to make, while the top layers take longer. It also helps to prevent cracking which can occur when thinned paint is applied on top of oil-rich paint. The technique can also be used with alkyds or acrylics.

**FUGITIVE** – a paint which fades over time or through exposure to light.

**GLAZE** – paint applied in a transparent or semi-transparent layer to modify the colour underneath. A glaze can intensify or dull down the colour beneath it.

**GOLDEN SECTION** – the division of a support along geometrical lines to create the 'perfect' proportions (see the Introduction). The rule of thirds is a similar, simpler method of positioning the main features.

**GOUACHE** – an opaque water-based paint which is handled much like watercolour. It is particularly popular with illustrators and graphic designers because of its bright colours and matt finish. Adding plenty of water to the paint makes it more like watercolour, but used neat it has good covering power and unlike watercolour it can be applied to coloured grounds.

**GROUND** – a prepared painting surface such as a primed canvas. The primer can be tinted in which case the surface is called a 'coloured ground'.

**GUM ARABIC** – the medium used in watercolour to bind the pigment. Additional gum Arabic can be added to make the paint more transparent and glossy. It needs to be added sparingly and is usually diluted with plenty of water first to ensure it is not overused.

**HP PAPER** – watercolour paper which is hot pressed to produce a hard, smooth surface. It is ideal for detailed work but the paint has a tendency to run very readily on it. Compare with Not and Rough Paper.

**HUE** – another word for colour.

**MIXED MEDIA** – the term used when a painting is worked in a number of different mediums. Such a painting might be worked in watercolour, gouache, coloured ink and pastel, for example.

**NEUTRALS** – colours which are hard to describe, often verging on grey or black. These are easily mixed from colours opposite each other on the colour wheel such as blue and orange. What one artist describes as neutral another artist might think is quite vibrant.

**NOT PAPER** – stands for 'not hot pressed'. Instead the watercolour paper is cold pressed to create a semi-rough finish. This is the most popular paper because it is the most versatile and ideal for both beginners and professionals. Compare with HP Paper and Rough Paper.

**OIL** – a painting medium made by combining pigment with oil such as linseed oil or safflower oil. Additional additives such as drier or wax may be used to improve the texture or speed the drying time, for example. Most manufacturers supply two ranges, one aimed at students and the other at professional artists. The students' ranges are generally less expensive because they use cheaper pigments and sometimes contain less pigment. It is perfectly acceptable to use paints from both ranges in a painting, if desired.

**PAINTING KNIVES** – literally knives used for painting. They have shaped blades, some quite long and thin, others short and wide which are almost heart shaped. Their cranked handles help keep hands clear of the paint surface and their pointed ends make a wide range of marks possible.

**PALETTE KNIVES** – literally knives designed to be used with the palette. These are used to mix colour on the palette, to scrape the palette clean or to remove paint from the painting. They have straight, flexible blades which are longer than those on a painting knife and the handle has less of a crank. Their blunt ends make it easy to lift paint off the palette.

**PASTEL** – sticks of pigment combined with chalk or clay and bound with gum. Soft pastels are the most widely used. Available in sticks, they contain a high proportion of pigment which means they are capable of producing really rich colour. Hard pastels contain more binder so they are firmer and create an effect more like that of a coloured pencil. Pastel pencils are pastels encased in wood and are ideal for adding detail to pastel or mixed media work or for artists who don't like the mess of soft pastels. Oil pastels are different again. They are made by mixing pigment with animal fat and wax and combine better with oil paints than with other pastels.

**PIGMENT** – pure dried colour which can be mixed with a binder such as gum Arabic, linseed oil or egg yolk to make paint. It is available quite finely ground from art shops but it may be necessary to grind it down further before mixing it into paint.

**PRIMARY COLOURS** – red, yellow and blue. These cannot be made by mixing the other colours but in theory they can be combined to create any other colour. In practice you need a warm and cool version of each and, unless you are using watercolour, a tube of white before you can mix most hues. Even then, it is much more convenient to have a few extra colours on your palette. Compare with Secondary and Tertiary Colours.

**ROUGH PAPER** – watercolour paper with a rough surface that allows the paint to settle in the hollows. This creates an attractive speckled finish. Compare with HP Paper and Not Paper.

**RULE OF THIRDS** – a means of creating aesthetically pleasing proportions in a composition. It involves mentally or physically dividing the support into thirds both vertically and horizontally and using these lines to arrange the composition. The points where the vertical and horizontal lines intersect are considered key positions.

**SECONDARY COLOURS** – orange, green and violet. These are made by mixing equal quantities of two primary colours. Compare with Primary and Tertiary Colours.

**SGRAFFITO** – the method of scratching away paint with a sharp tool to create texture.

**SPLIT COMPLEMENTARIES** – not quite complementaries. The true complementary of blue is orange, so a warm yellow would be its split complementary.

**STAINING** – a paint which stains the paper it is applied to so that it can't be removed or which seeps into overlaid colours.

**SUPPORT** – the paper, canvas, panel or board on which the painting is made.

**TERTIARY COLOURS** – these include blue-green and red-orange. They are made by mixing equal quantities of a primary with the adjacent secondary. You can continue this process to mix a tertiary with a secondary and so on to create a subtle range of colours. See also Primary and Secondary Colours.

**THINNER** – the substance used to dilute paint. For oils this traditionally means turpentine while for watercolour and acrylic the thinner is water.

**TONE** – the lightness or darkness of a colour as if the subject is seen as a black-and-white image.

**TONKING** – a method of removing excess oil paint from a picture to speed up drying named after its inventor, Sir Henry Tonks. It simply involves pressing a piece of absorbent paper over the wet paint and then peeling it off to remove some of the paint. The paper should not have any printed or handwritten text on it otherwise the ink may dirty the paint.

**UNDERPAINTING** – one of the first stages of a traditional oil painting when the elements of the composition have been painted in monochrome or very soft, bland colours. The tonal values are defined at this stage. Some artists refer to this as 'laying in'.

**WATERCOLOUR** – a painting medium made by combining pigment with gum Arabic. A little glycerine helps to prevent the paint cracking. The quality of the paint depends mainly on the quality of the pigments used, so it's always advisable to choose a reputable brand.

**WET-IN-WET** – a term used to describe the watercolour technique of applying paint to wet paper or paint so the colour(s) flow and combine. It is very difficult to predict exactly what will happen with this technique but it can produce some wonderful results.

**WET-ON-DRY** – the opposite of wet-in-wet, which simply means applying watercolour to dry paper or paint. The colour dries to form a hard edge which is useful for defining say, the trunk of a tree.

# Further Reading

For information about paint colours and colour mixing you can't do better than the books by Michael Wilcox published by the School of Colour Publishing. These include 'The Artist's Guide to Selecting Colours' (ISBN 0-95878-918-5) and 'Blue and Yellow Don't Make Green' (ISBN 0-95878-919-3).

For information on specific techniques try the encyclopedia range of art books published by Headline. These include 'The Encyclopedia of Watercolour Techniques' (ISBN 0-74727-949-7); 'The Encyclopedia of Acrylic Techniques' (ISBN 0-74721-068-3); and 'The Encyclopedia of Pastel Techniques' (ISBN 0-74727-843-1).

Beginners interested in step-by-step techniques may like to refer to the painting series by Patricia Monahan and Jenny Rodwell published by Studio Vista. These include 'Oil Painting' by Patricia Monahan (ISBN 0-28980-058-7) and 'Painting in Pastels' by Jenny Rodwell (ISBN 0-28980-073-0).

# Acknowledgements

Many thanks to Brenda Dermody who designed this book so beautifully and to Julien Busselle for his wonderful photography. My thanks also go to Winsor & Newton for supplying many of the materials used in this book and to Zoe Spencer for tracking down the artists in the first place. This book would not have been possible without the participation of the artists and the inspiration of Angie Patchell at RotoVision, or without the courage of Brian Morris who agreed to produce the book.